2 W9-AHP-237 To Joe Care · who reincue quetitude for your contributions to The Americania of Pare oblighter Wariel Van Diagona Decens ben 21001

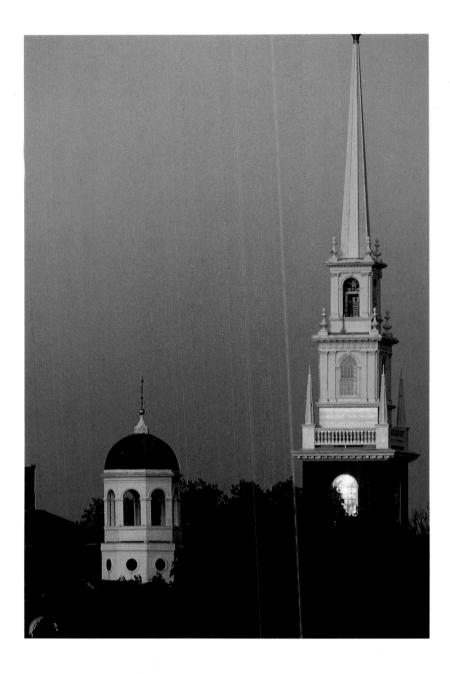

Photographs copyright © 1998 Steve Dunwell Copyright © 1995 Steve Dunwell

This book or portions thereof may not be reproduced in any form without the permission of Back Bay Press. Photographs may not be reproduced in any form without the permission of Steve Dunwell.

Edited by James B. Patrick Designed by Donald G. Paulhus

Printed in Hong Kong through Palace Press International

Library of Congress # 95-078282

ISBN #0-9643015-1--2

Revised fourth printing 1998

Published by Back Bay Press 20 Winchester Street Boston, MA 02116

HARVARD A LIVING PORTRAIT

Photography by Steve Dunwell, Introduction by David McCord

Yovey, still the ascending critic and musicologist of Edinburgh, lectured to us on Beethoven. Not in the lecture I heard him give, but in his extraordinary, amiable, and often witty prose, he ultimately examined the Ninth Symphony literally stave by stave. So now a fine photographer, Steve Dunwell of Boston, has examined through something like eleven thousand photographs, of which one hundred and twenty-four comprise this book, the visible symphony of our College and University — Harvard and Radcliffe — in depth and in minute detail: brick, stone, doorways, windows, towers, stairwells, rooms, studies; libraries, laboratories; nooks, crannies, trees, shrubs, ivy; the campus which we call the Yard; the strange composite charm of the physical ambiance itself. This is not a book of people, students, faculty, librarians, administrators, scholars, and athletes. It is simply the clear anatomy of academe: a sojourn and a journey all in one.

A sojourn and a journey through pages wholly suited to a triple audience: to Harvard and Radcliffe students, faculty, and staff, past and present; to the thousands of Harvard visitors day in day out who may remember nothing but the half-believable look of the tranquil ancient Yard and the unbelievable reality of the precious Glass Flowers in the Museum of Comparative Zoölogy; and to those who have actually never set foot in Cambridge, but have often wondered: "Who is Sylvia? What is she?" A book, in short, to offer at once a conspectus for those who know or think they know their Harvard; a stunning folio of remembrance for those who seek the *déjà vu*; and a revelation to those who have not yet passed through the gate over which it says with confidence undiminished after all these years: *Enter to Grow in Wisdom*.

As of course, if that directive were actually followed by an undergraduate or graduate student, the growing would naturally advance season by season; so with this book in your hand, for the photographs are arranged by seasons. And arranged with a sensitive control of continuity. Now no sequence of pictures of anything, architecture and environment included, can be expected to flow as with the exquisite primitive mitering of those lofty stones in Machu Picchu, or with the classical guitar in Francisco Tárrega's lovely "Caprichio Arabe"; but all the same, this book is not without a bit of magic in the inevitability of its visual progress page to page and season to season.

Tow when young Francis Parkman wrote *The Oregon Trail* in 1846, he had crossed the wide Missouri into a frontier history of which he is himself a part. Henry David Thoreau, six years Parkman's senior, did his travelling round and on a Concord pond named Walden; and for him as for Parkman — as indeed for Emerson in Emerson's own words — "art is the path of the creator to his work." And just as it was with those two sons of Harvard, so it was with the ethic of their College; and so it is philosophically with their University today. Had Parkman and Thoreau been equipped with the fool-proof cameras and color film of the 1980s, what a pictorial record would be ours of a time now totally vanished! As Whitman, another but non-Harvard contemporary, two years Thoreau's junior, has said: "All music is what wakes you when you are reminded by the instruments."

Well, the instruments in this book, being in fact such shrewd but random impressions of what was seen in varying light and often shot from surprising angles, have assembled themselves to waken or remind you, page after page, in the exact measure of the ranging intelligence you

would bring, let us say, to the galleries of a great museum. Indeed, come to think of it, you will be — you already *are* — inside a museum.

Consider first the Harvard Yard. Much as L'Enfant laid out the city of Washington, the ghost of Euclid may have had a hand in arranging reading clockwise — the old north part of the Yard with the bricks of Massachusetts and Harvard Halls, Hollis, little Holden Chapel, Stoughton, Holworthy, tremendous Thayer, and Bulfinch's University Hall made of granite. Why, so compact, so orderly, so tidy is this area that the lenses of two eyes are wide-angled enough to take it all in at a glance.

-arvard has had many architects. The names of some that I forget will occur to you as you study the photographs. I think offhand of Bulfinch, Richardson, Coolidge, Shepley, Le Corbusier, Ware & Van Brunt (Memorial Hall), Gropius, Sert, Stanford White, Stubbins; and Yamasaki. Now it is certain that not every reader will find a picture of everything he or she is looking for; but how can this be helped? I myself miss, for example, a closeup view of any one of the splendid medallions — say a particular starfish — on the glass and bronze doors of the Biology Laboratory: the work (and a masterpiece to my mind) of the sculptor Katharine Lane Weems. Other readers, however, will be surprised and delighted by something here and there never noticed until now. In my forty-six years at Harvard there must have been a dozen doorways in all that thrombus of structures which I never entered. But for the average alumnus or alumna, and for all who *really* know their Harvard and Radcliffe, what this book almost promises is to bring back instantly and vividly some bright fragment of an event half forgotten. I well remember coming out of Jefferson Laboratory from

a physics class (electrons and radium) and looking up into an empty blue sky in the nick of time to see a meteor (asteroid) explode by day, But soundless with the stale report Of ancient wars and dragon snort.

What a sight! And I also remember — reminded even as I sampled the early drafts of this book — stepping out of the Faculty Club one late autumn night to find myself for one rare, rare, impossible moment standing precisely beneath the open cone of a brilliant aurora borealis display, and looking up into that awesome distance through the grand-ure hanging above me as if into a godlike, frightening infinity.

Returning to that physics laboratory and to physics: everything in the pages which follow reminds me of my 1921 classmate and fellow concentrator in that abstruse field. He was Leopold D. Mannes, nephew of Walter Damrosch, himself a fine musician who as a freshman was, surprisingly enough, the holder of a number of international patents in color photography. Together he and I built a telescope and with it looked on the available moons of Jupiter and (I think) on the faint rings of Saturn. But his great accomplishment with his co-inventor, Leopold Godowsky, was to do the research which led to Kodachrome and the Franklin medal. Something of Leo is therefore in these words of mine in a book which his genius helped make possible.

s for Radcliffe College, now an integral part of Harvard, in 1979 I said, in a rarely-used verse form called "runover rhyme", what seemed to me important to say on the occasion of her one hundreth anniversary. I thought at the time — and I still think — that runover rhyme suited the nature of this celebration better than the sestina, or English-Greek sapphics, two forms which I rejected.

Radcliffe in Runover Rhyme

Radcliffe, you never could cherish it. Perish the thought of a C! Your primitive sundial and gnomon in Roman employ X, I, V alone, or combining these three.

Yet now, as you reach your centennial, many'll tell you: Don't break with tradition! But C, as you earn it, is—durn it—just what you must take: C, hundred; C, candle; C, cake.

No talk of us being your betters. All letters are yours to invoke: A, Agassiz; B, Briggs; C, Comstock where *I'm* stuck, for rhyming's no joke. Bless your alphabet's English as spoke

in those Jamesian days: Neilson, Baker (caretaker of theater); Doc and the Choral Society, glorious Praetorius . . . Horner and Bok, present Presidents, such was pre-Rock. In the gym toiled a ballet in bloomers. Rumors of wars hot or cold hadn't reached you, dear Lady-in-Waiting creating—too young to grow old. Lady Mowlson, Ann Radcliffe: behold

all these pleiads of scholars, of teachers; outreachers in science, in art; astronomers, doctors, achievers; believers in something apart in the head undivorced from the heart;

revelation that made Helen Keller your stellar alumna, revered to this day. Is her Greek *analeptic* (not *septic*) a word unendeared? By your light, up through darkness she steered.

So it be. Let us say life was given, not driven. These hundred years on, "The habitual vision . . ." before us, to chorus: The Queen, not the pawn! It is day. What you've had was the dawn.

If you will accept that notion of looking at this book as though you were in the gallery of some great museum, consider what it is to face a landscape by Corot, Peter De Windt, Bierstadt, or Innes, unable to name the trees, valleys, flowers, rivers, mountains, and then (as by magic) to be given all these variants in detail, and out of them reassemble the painting or watercolor itself. Take such a view, and this book should help you to answer Shakespeare's question: "Who is Sylvia? What is she?" But all I can do to assist the reader who has *never* seen Harvard is to quote myself in the following summary of what my College and my University have meant — and mean — to me:

-arvard has given great men and great ideas and great citizens and great teachers to the nation; she has seen us through nearly a dozen wars. She has given us six presidents of our country; she has stood like a rock in our midst. She has weathered criticism just and unjust, and abuse which is never just; she has looked at her own faults, which have been not a few, and has striven to correct them. She is far from perfect, but she knows that perfection is nothing more than the perpetual will to seek it. If she was ever the rich man's college, she is just as much the poor man's college today; for her sole requirement of the entering student is that he or she have character, ambition, ability, and the capacity to learn to think for himself - for herself. She is not prejudiced with respect to race or creed or color. She is able and eager to help those who enter her gates. She is anxious to be one thing above all: a better Harvard tomorrow than she was yesterday. To that end, she is permanently for change, but always with an eve to the unchanging values of the human spirit. Lastly, and most important, she has faithfully stood for freedom of the mind and the dignity of the individual; and never more so than in the strange, abrasive period which has followed World War II. As one alumnus once wrote to my office: This gift is "for the institution that represents one of the great achievements of American democracy."

David McCord

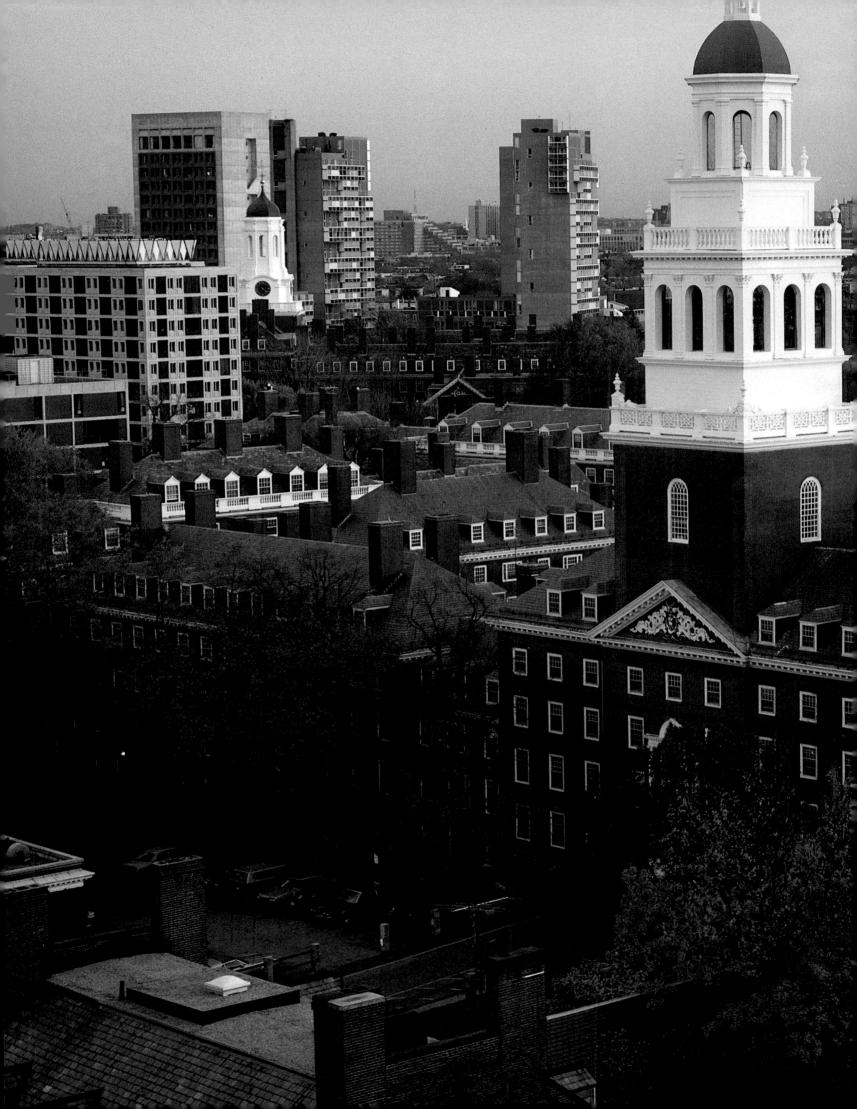

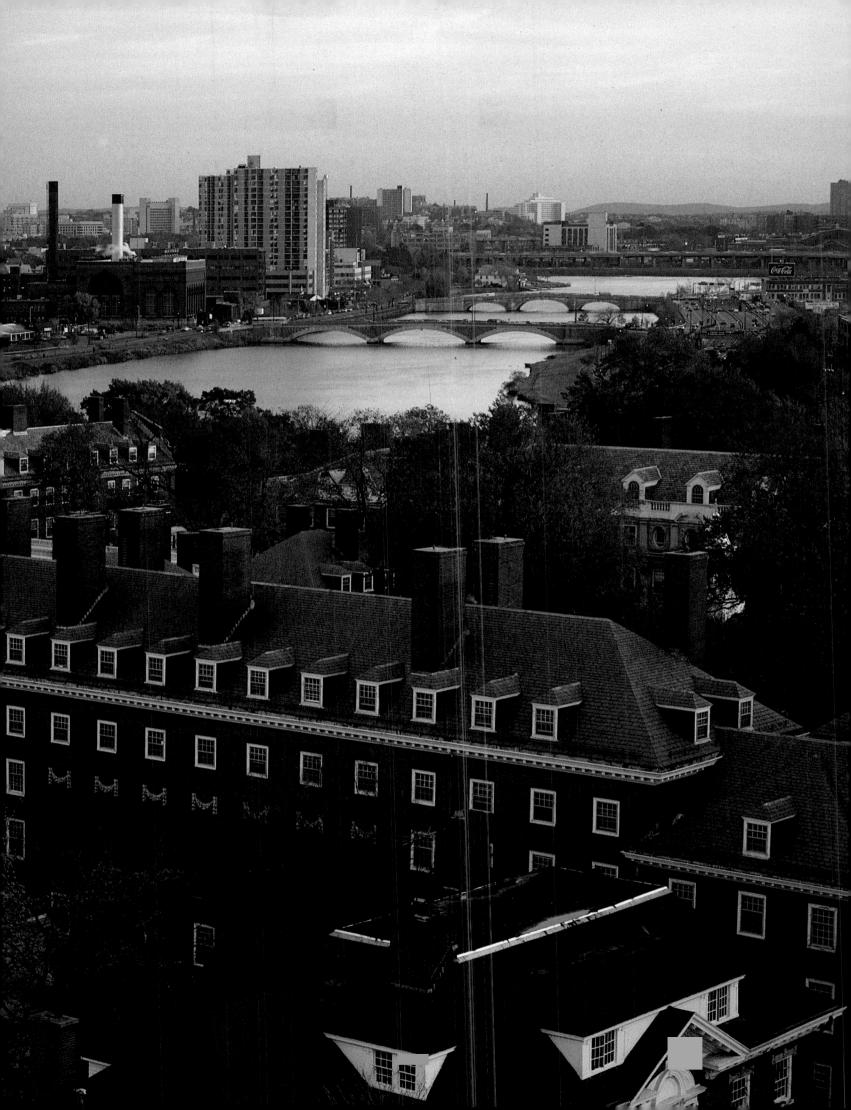

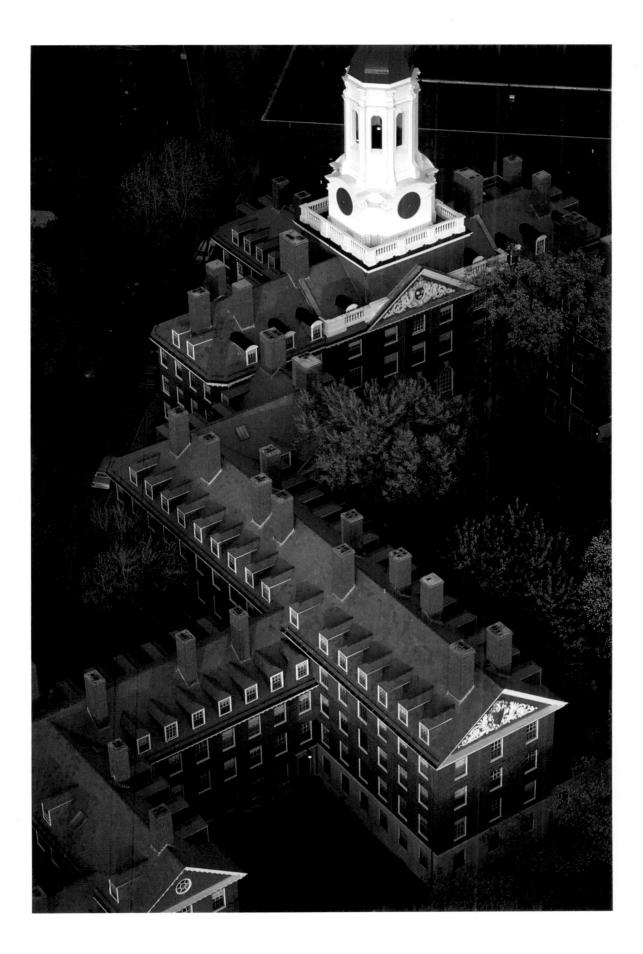

Dunster House

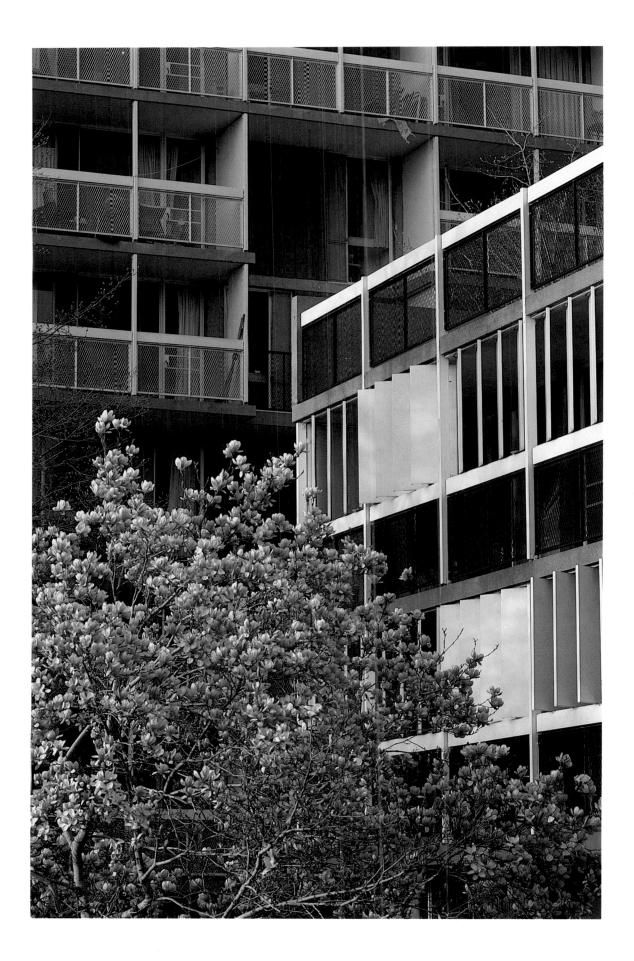

Peabody Terrace

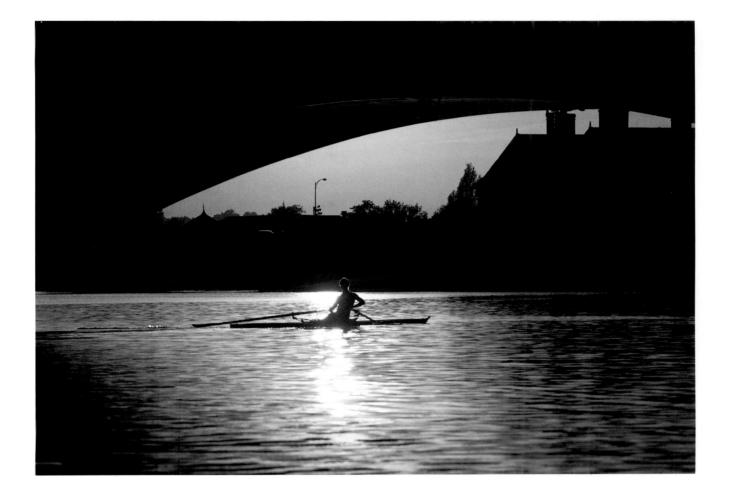

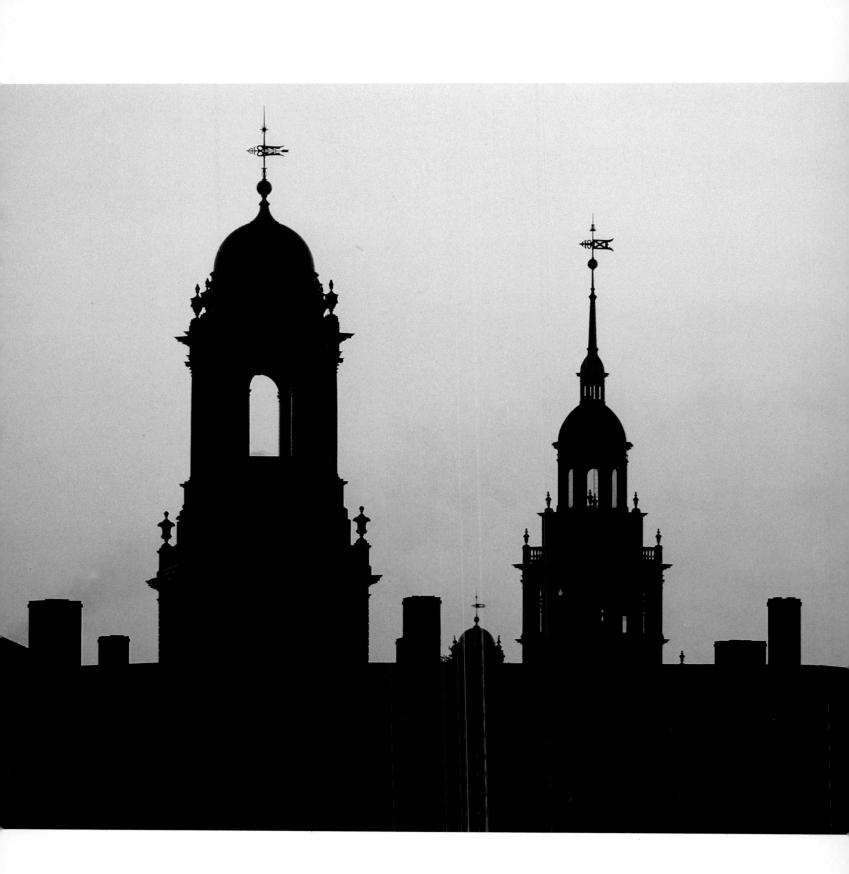

Sunrise silhouettes Eliot, Adams, Lowell towers

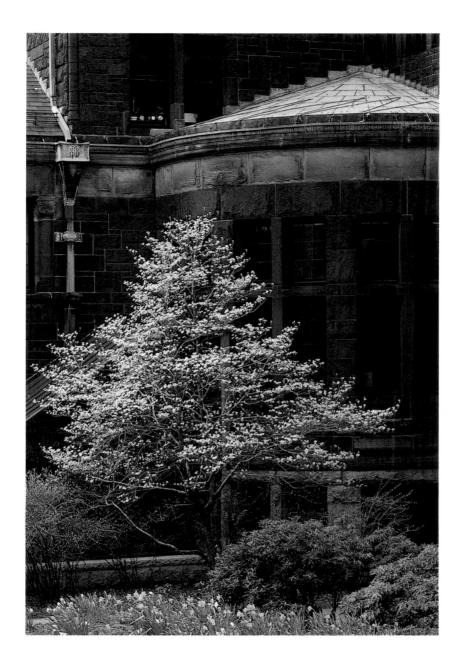

Austin Hall dogwood

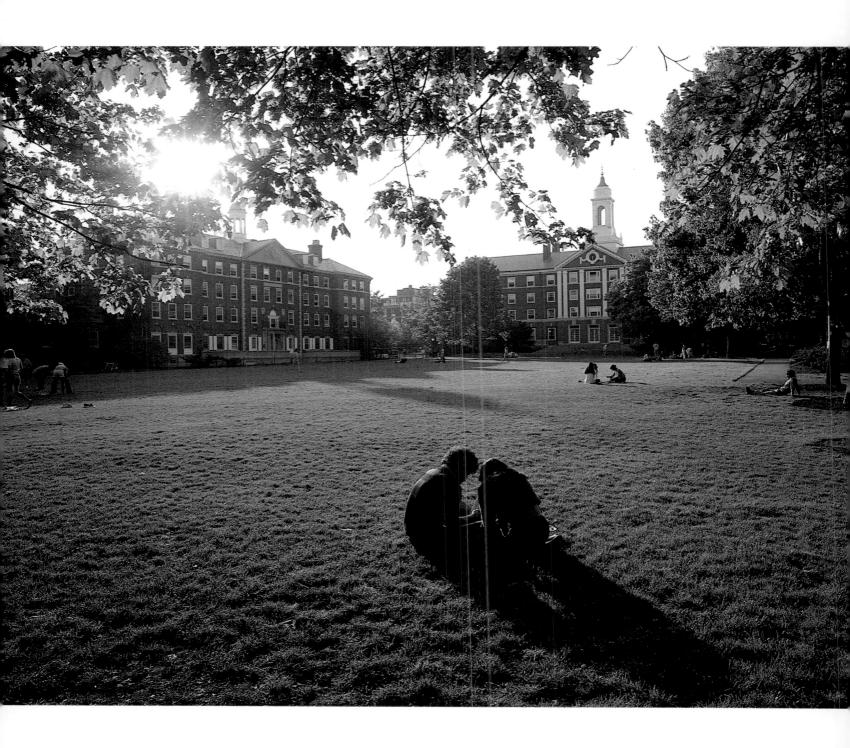

Late afternoon on the Quadrangle

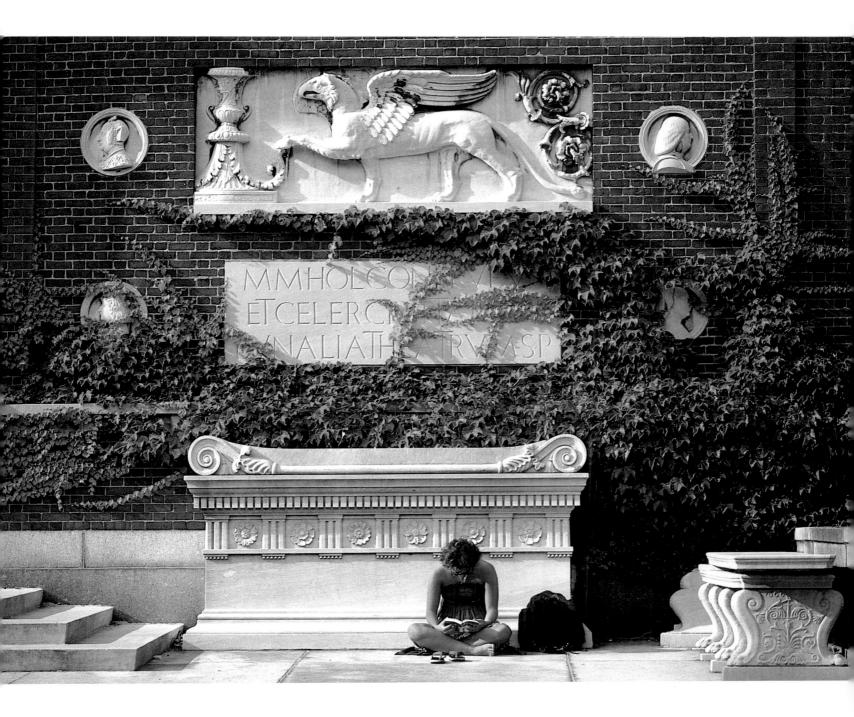

Robinson Hall

Westmorely Court, Adams House

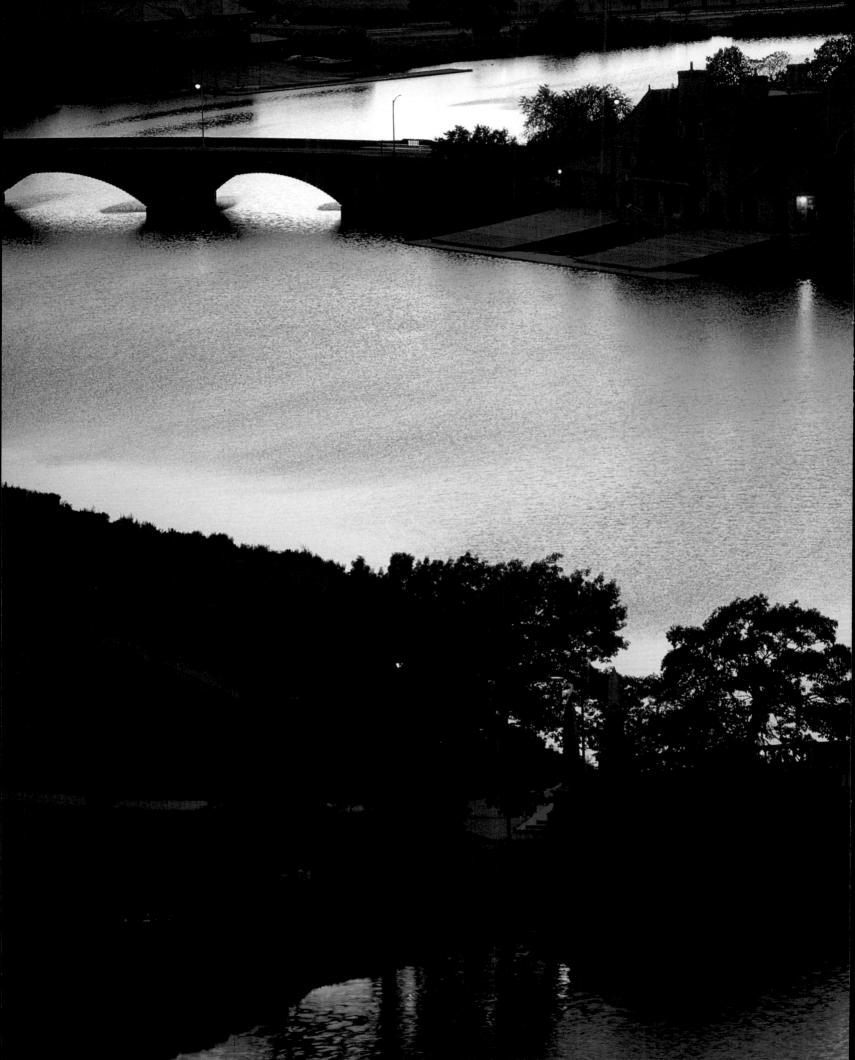

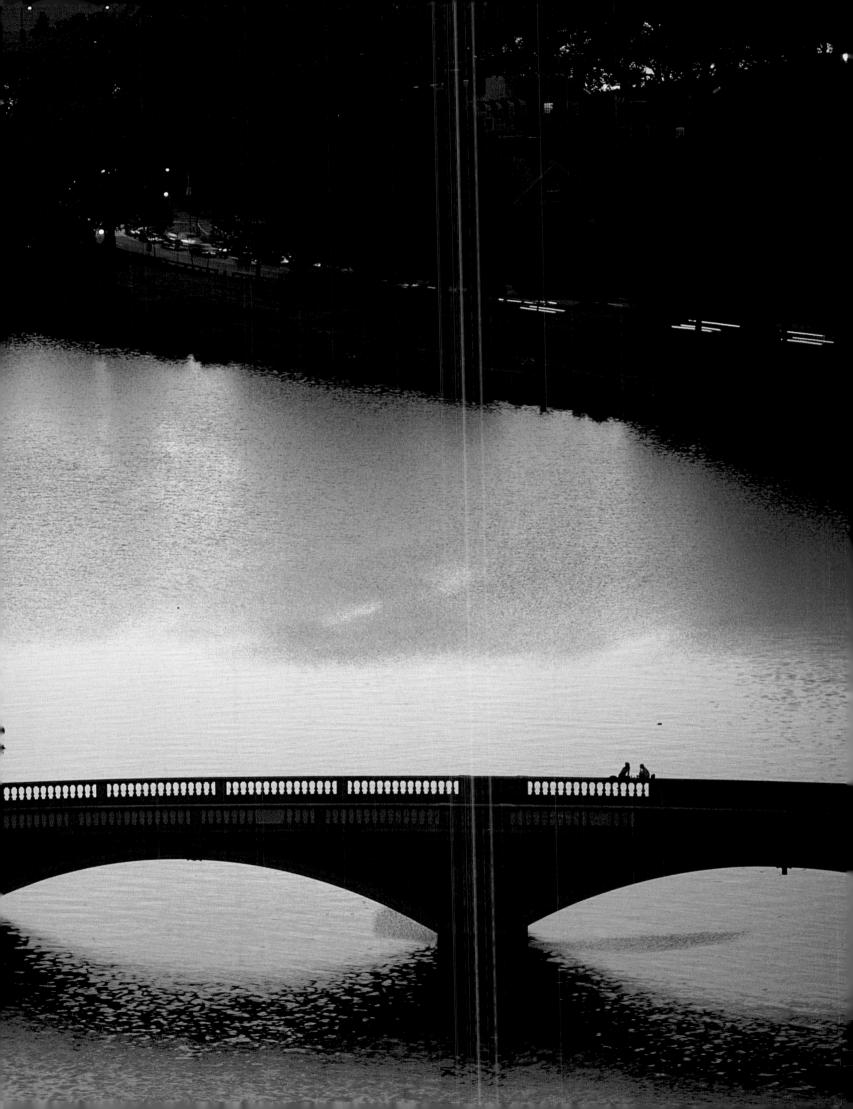

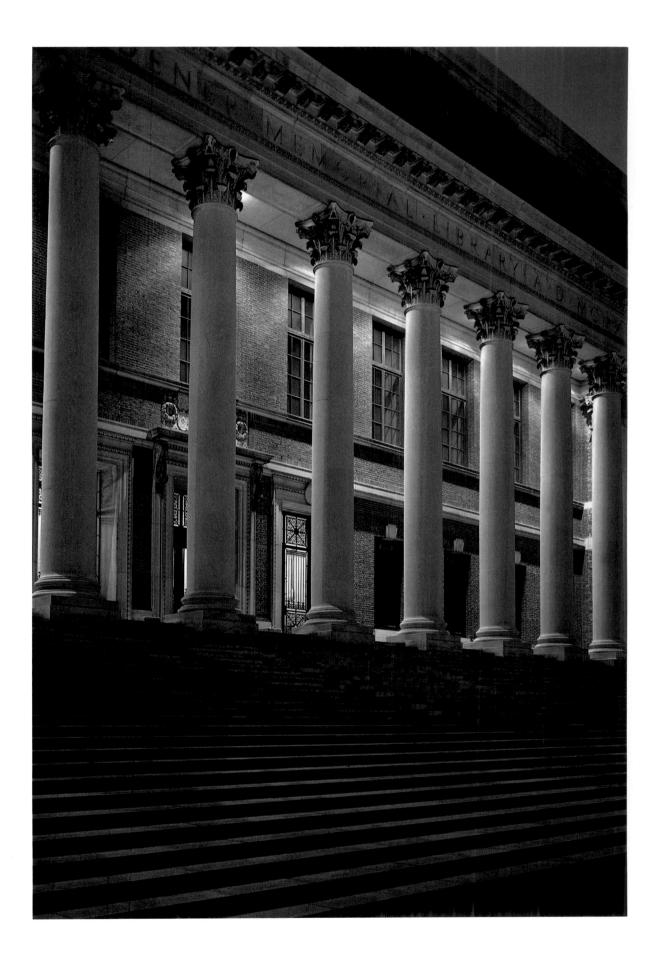

Dusk at Widener Library

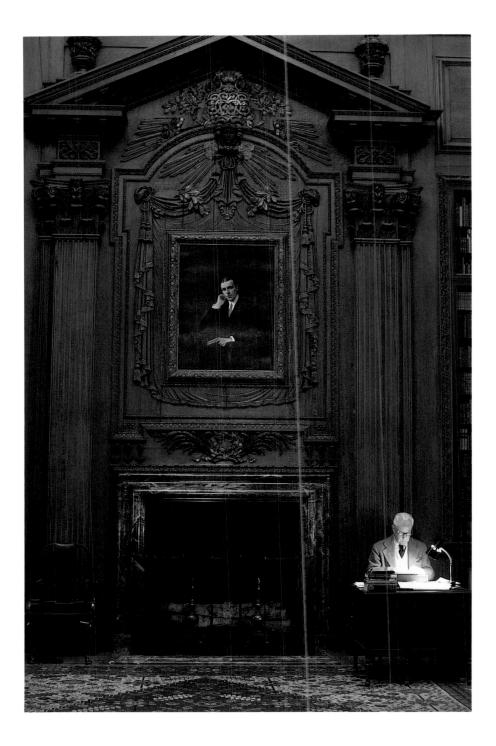

Widener Memorial Room

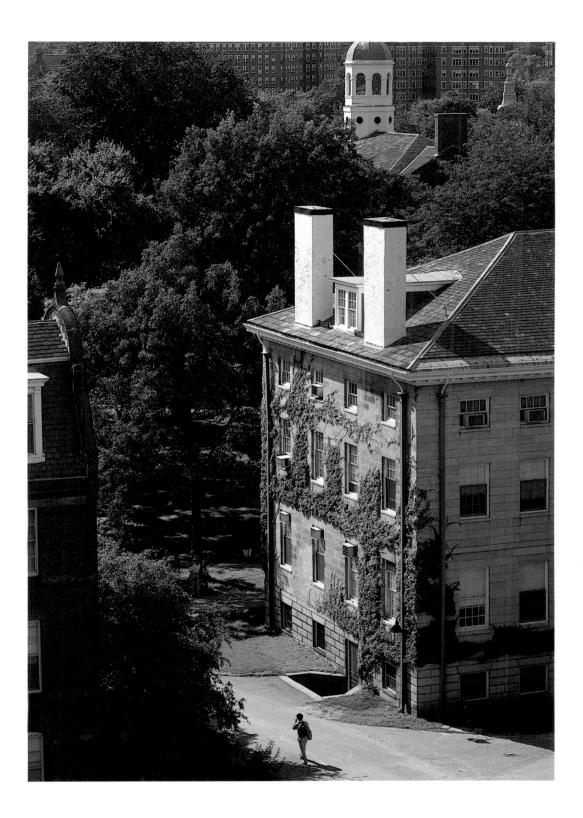

Twin chimneys at University Hall

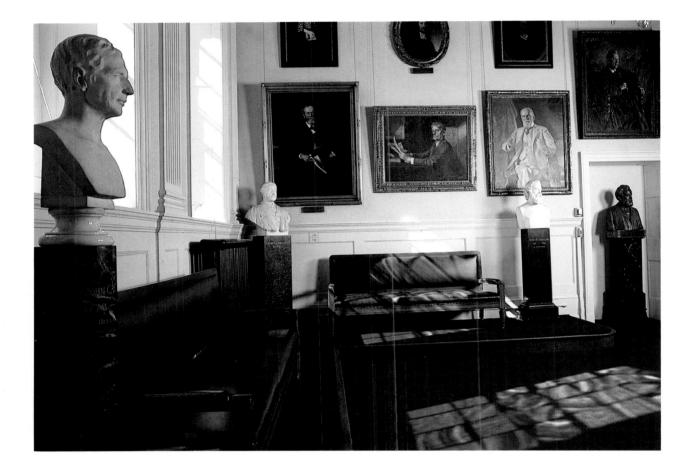

Faculty Room, University Hall

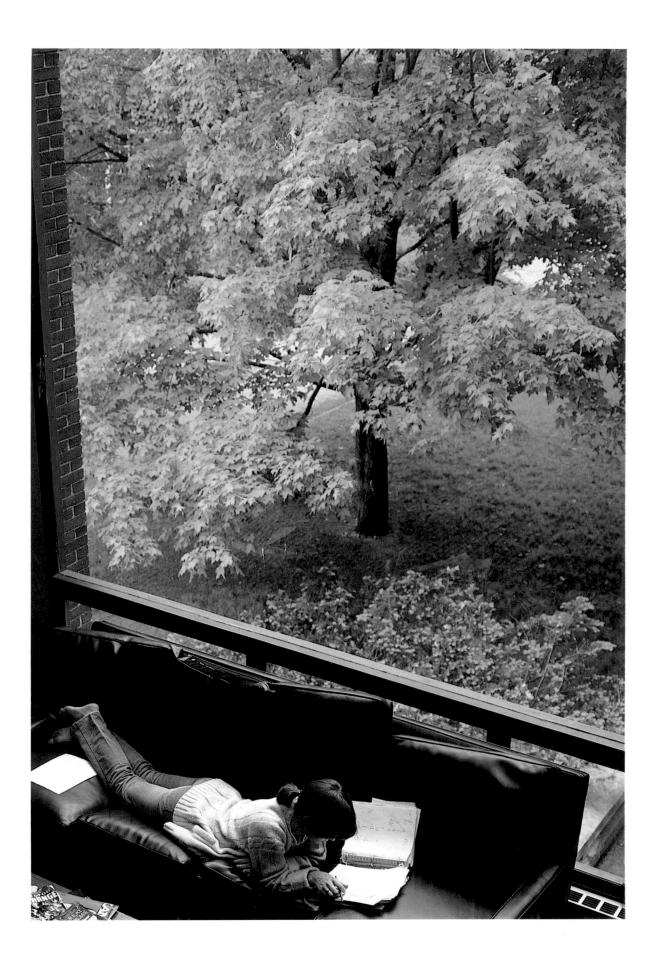

Quincy House

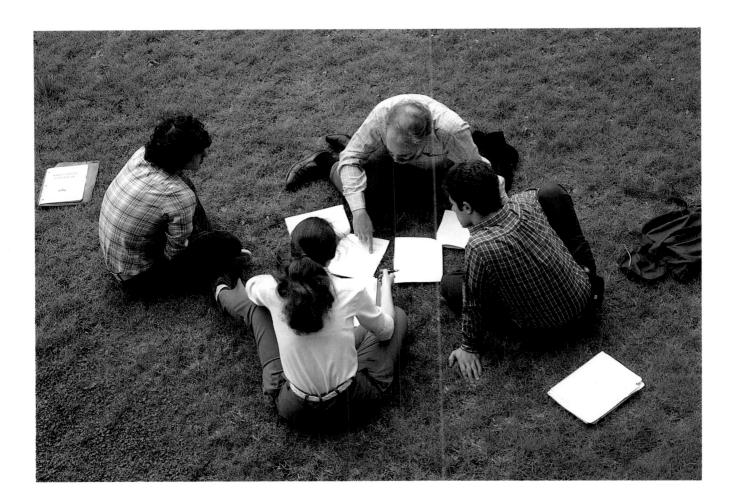

Tutorial, Aiken Lab

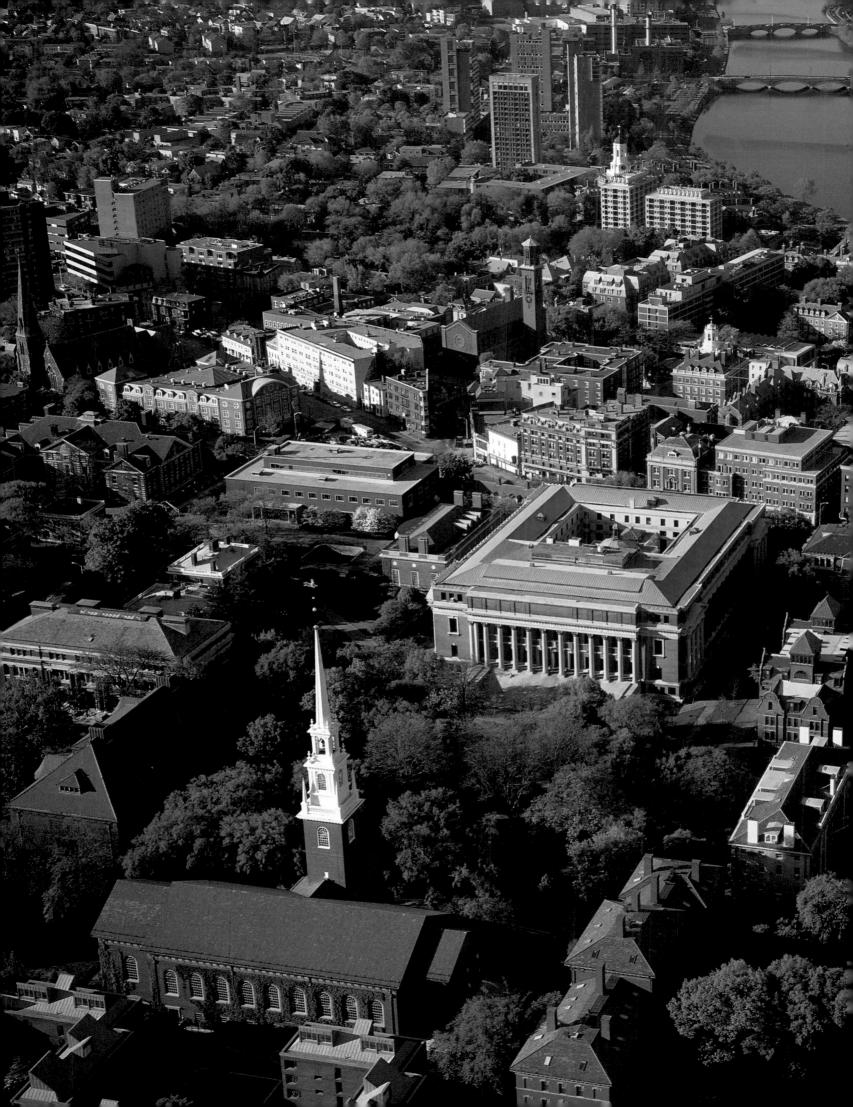

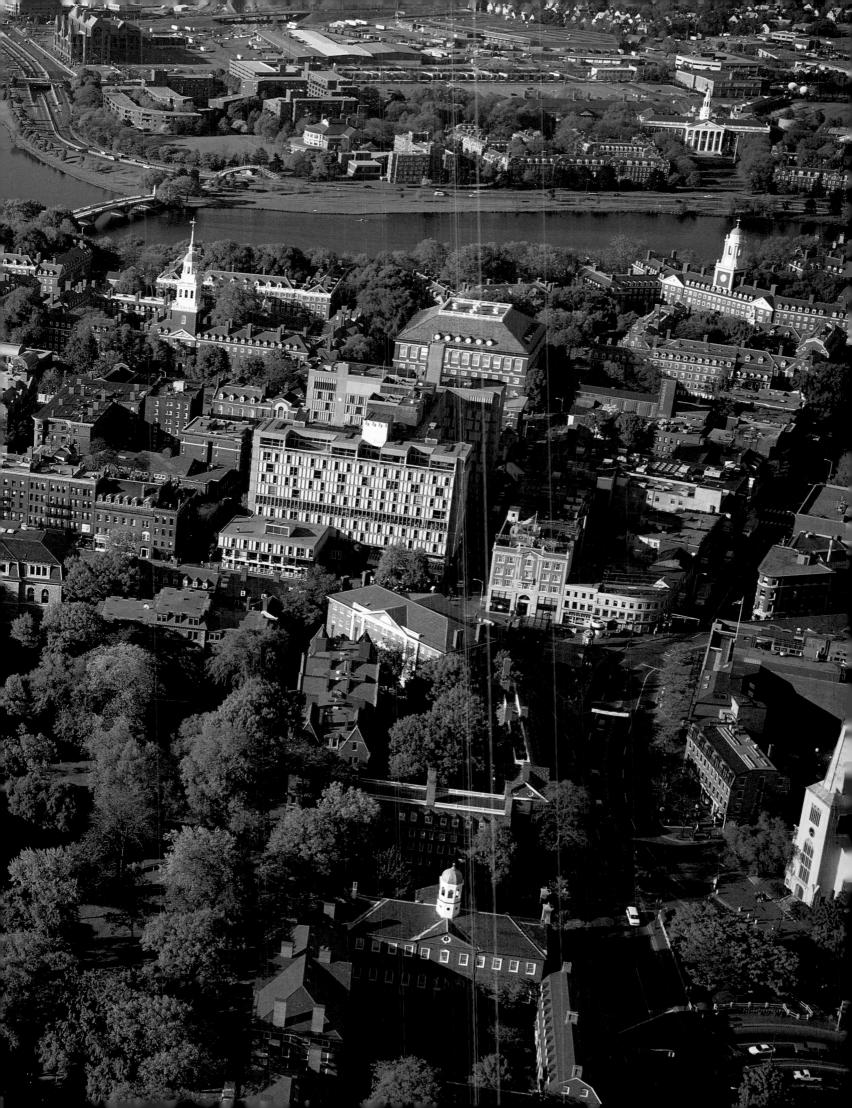

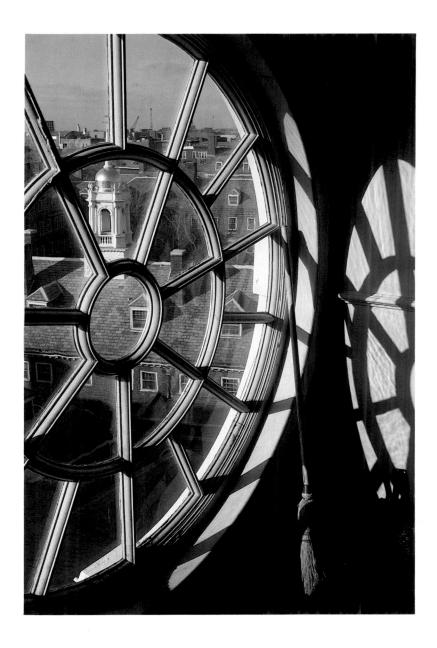

Kirkland House, from Eliot tower

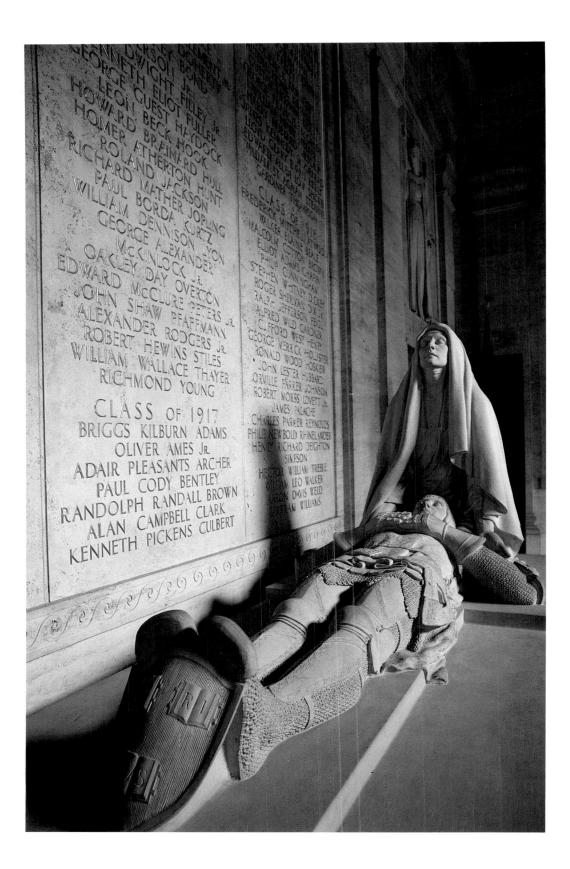

Memorial Church

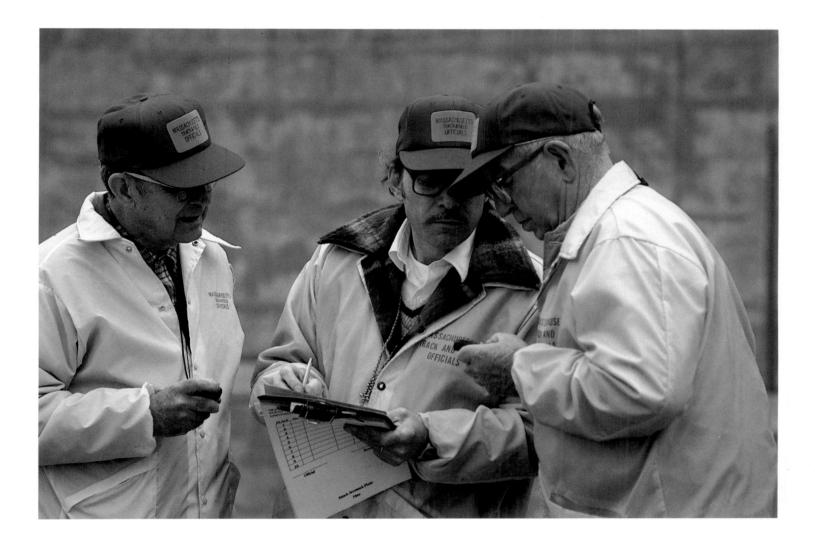

Track officials confer at Dillon Bowl

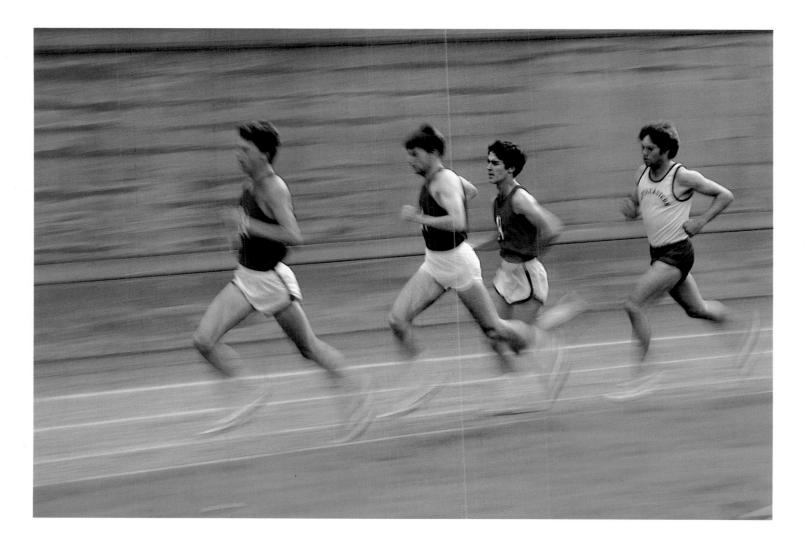

The kick - 1000 meter race at Harvard Stadium

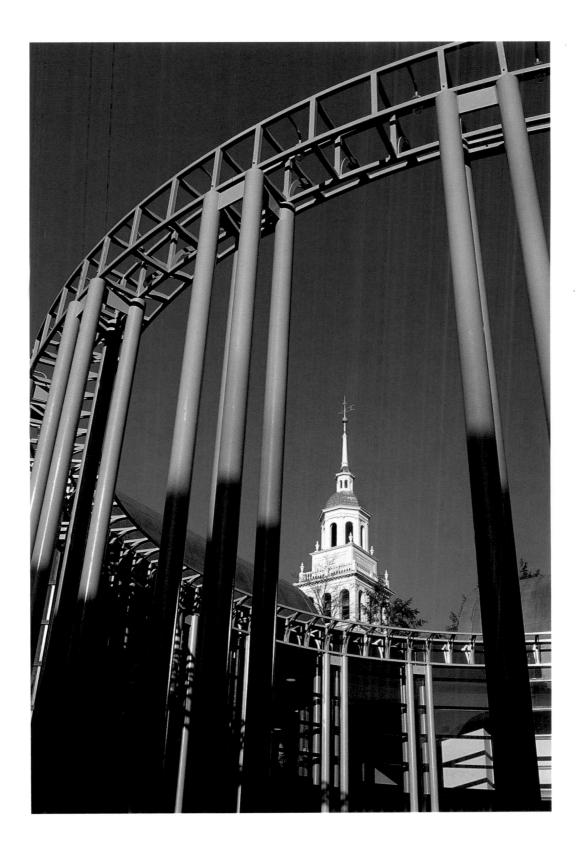

Riesman Center at Rosovsky Hall

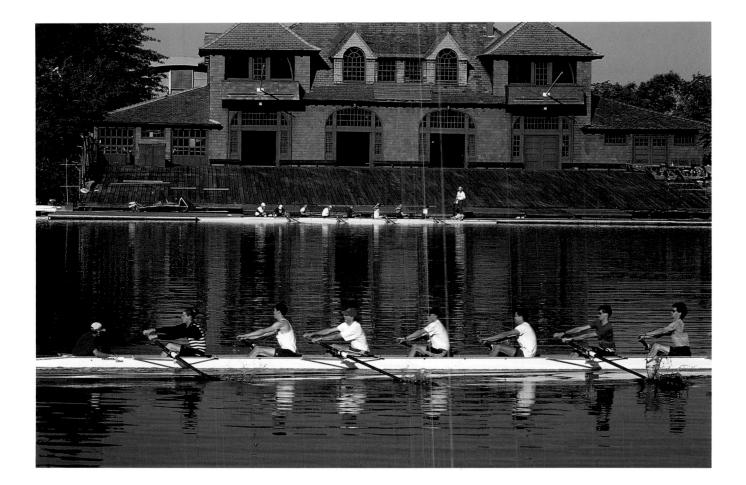

Newell Boat House

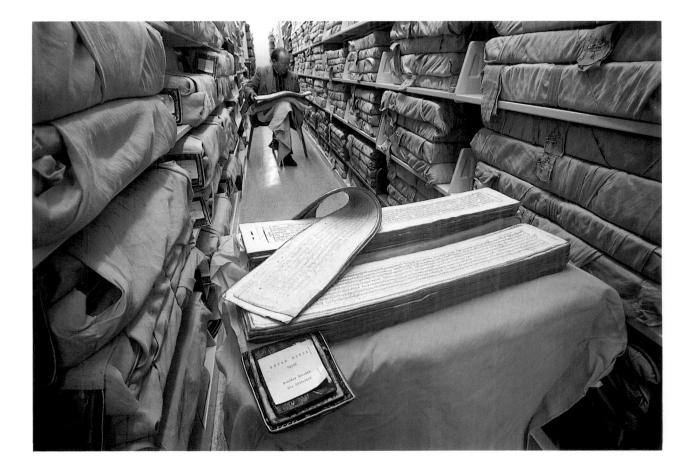

Tibetan manuscripts, Yenching Library

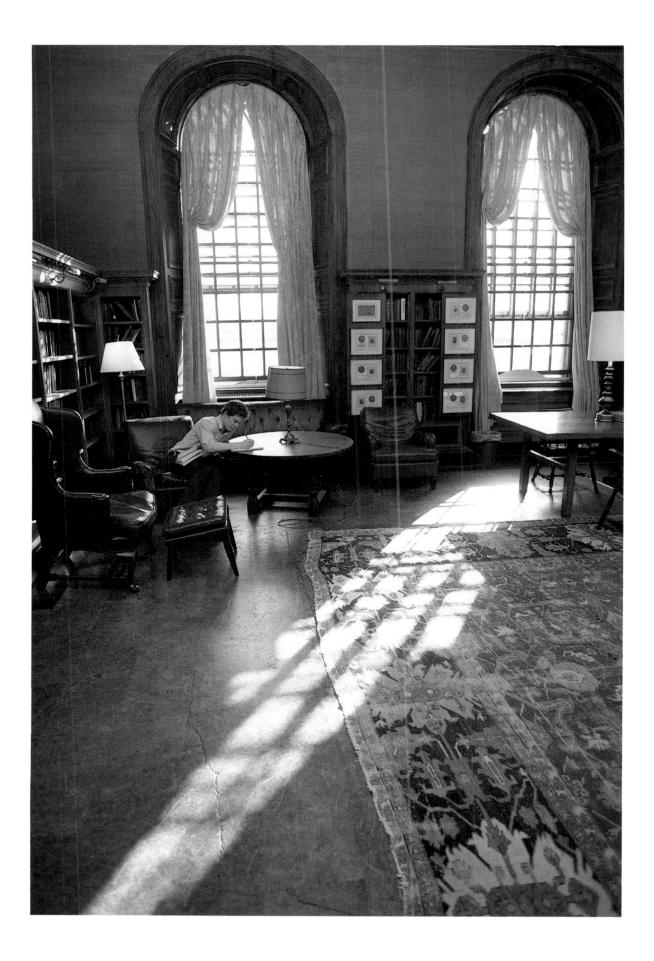

Eliot House library

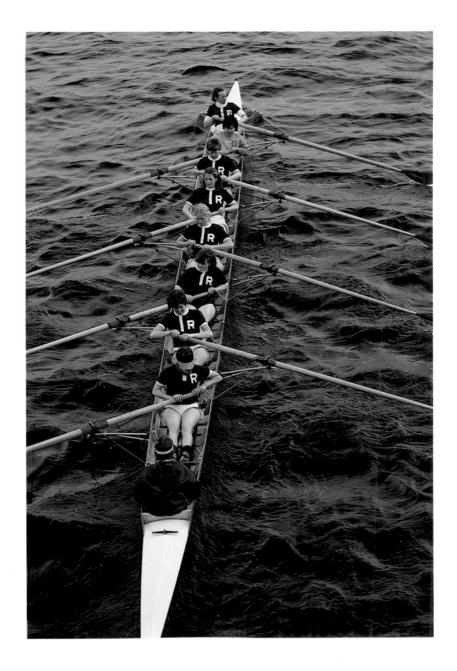

Radcliffe crew, from Weeks Bridge

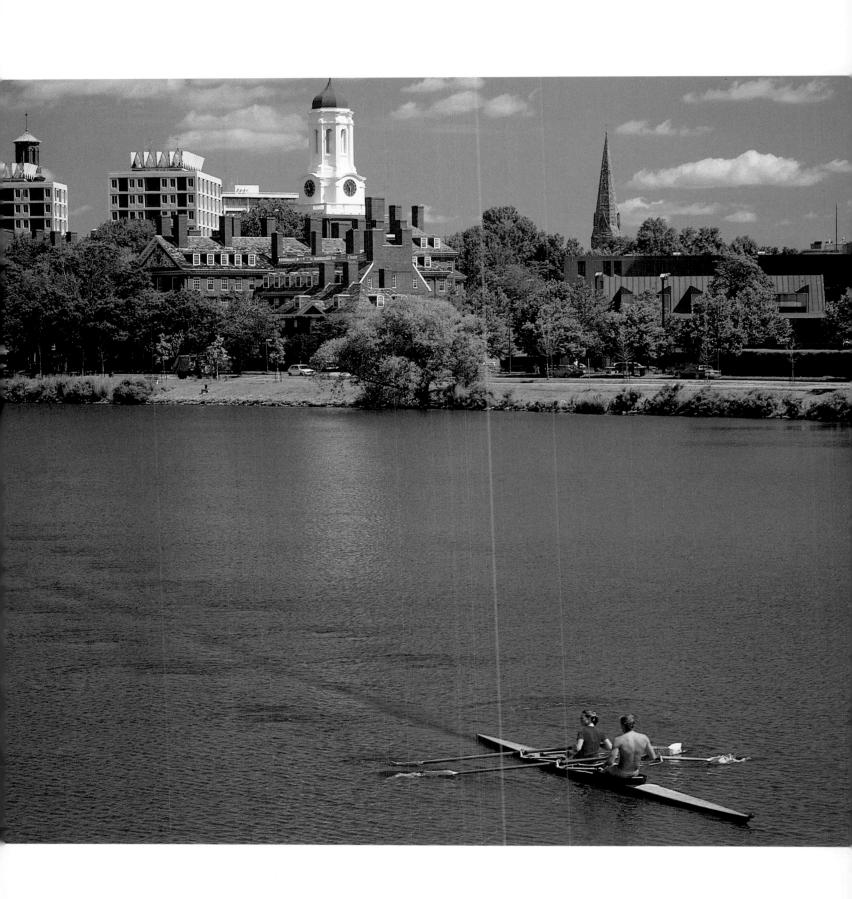

Tandem scull, Dunster House

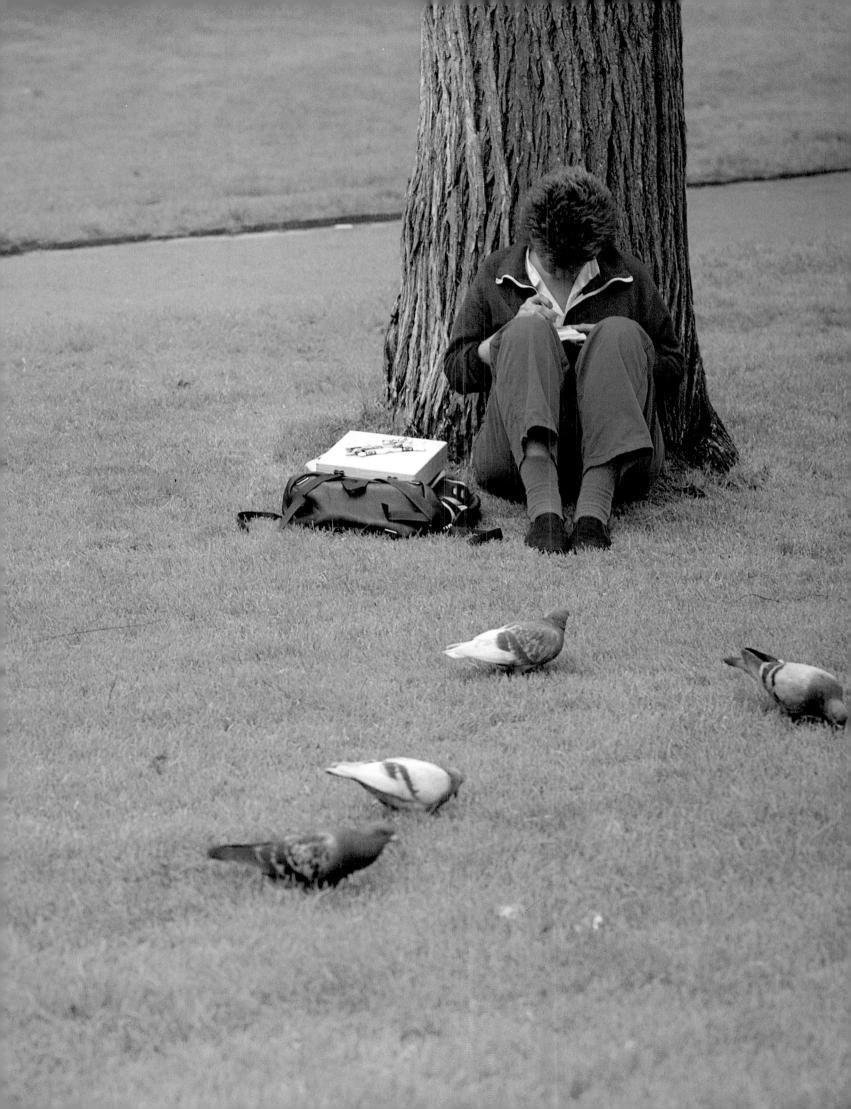

Fountain at Adams House

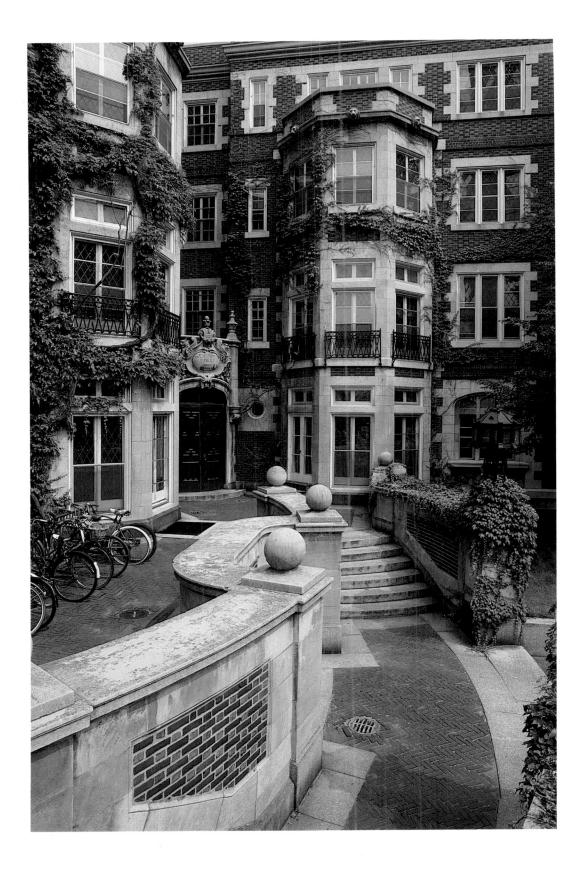

Adams House

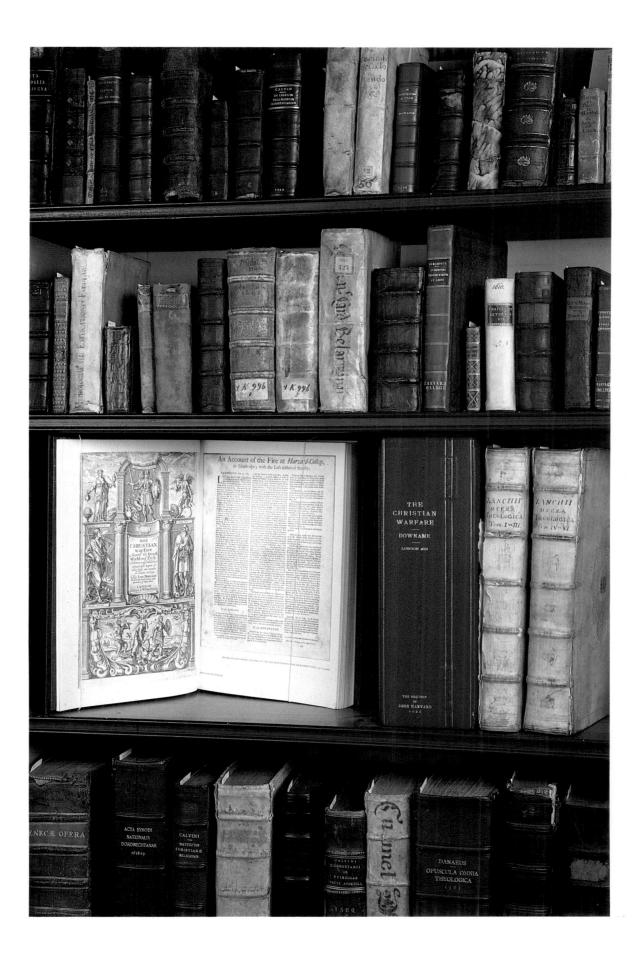

Houghton Library

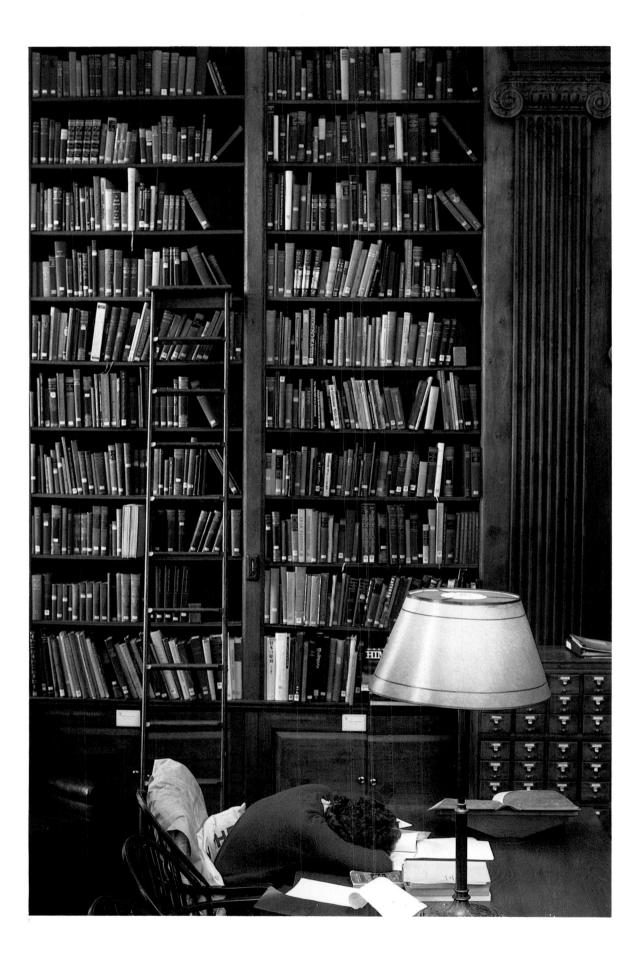

Dunster House

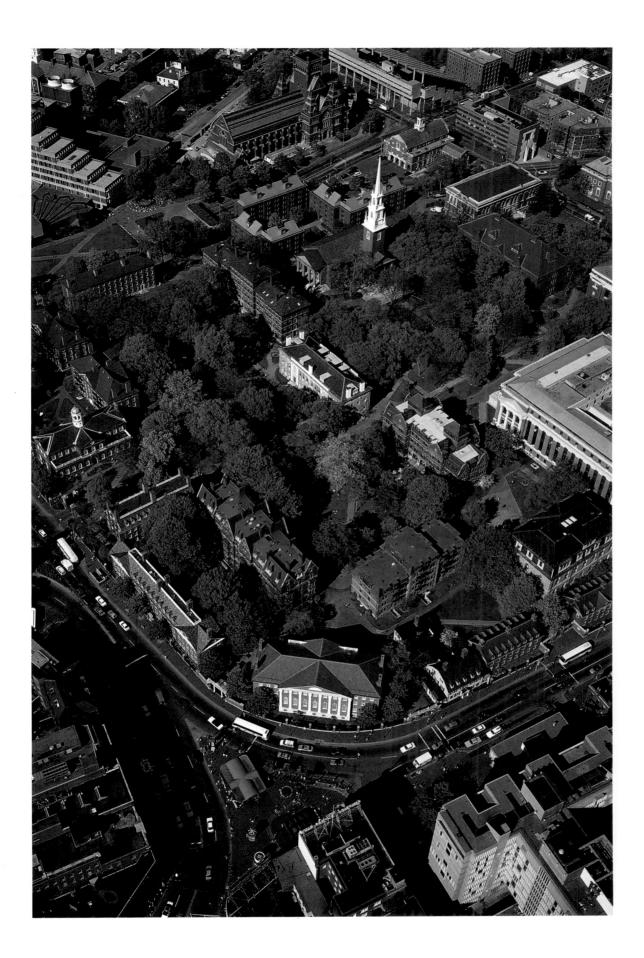

Harvard Square

Gund Hall

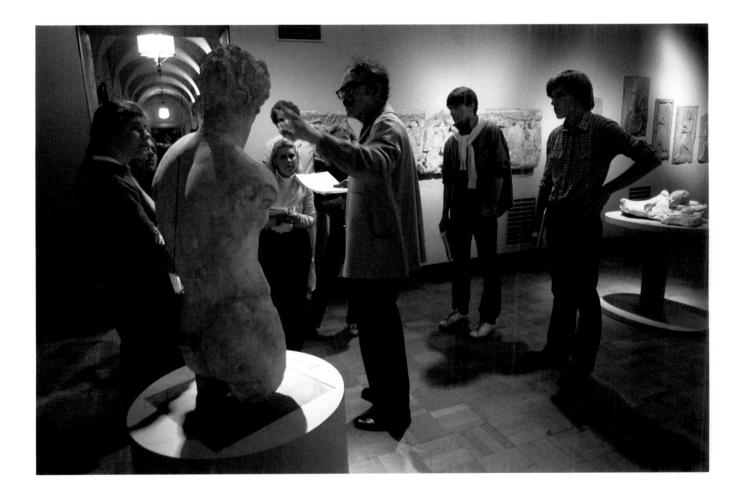

Studying Roman Sculpture, Fogg Museum

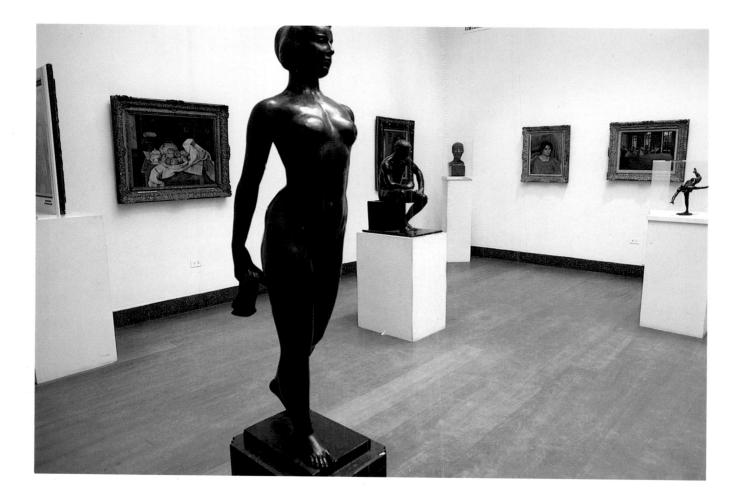

Maillol's "Ile de France," Fogg Museum

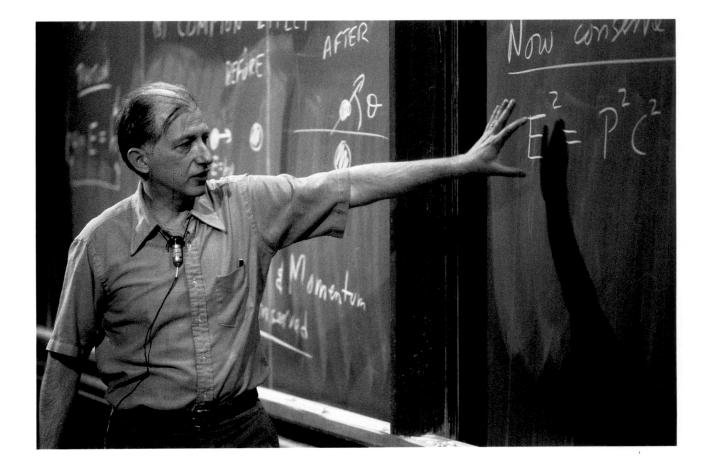

Physics lecture

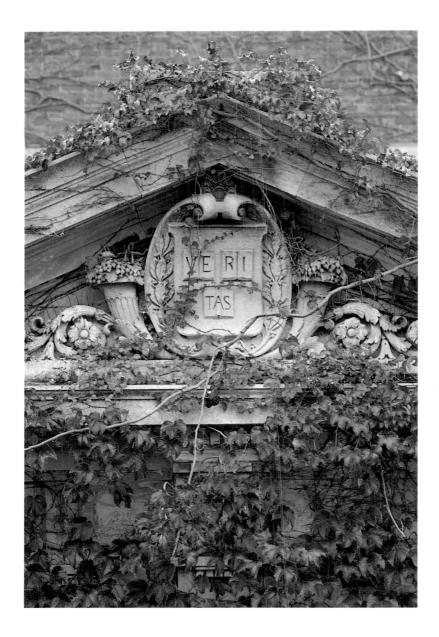

Gateway pediment

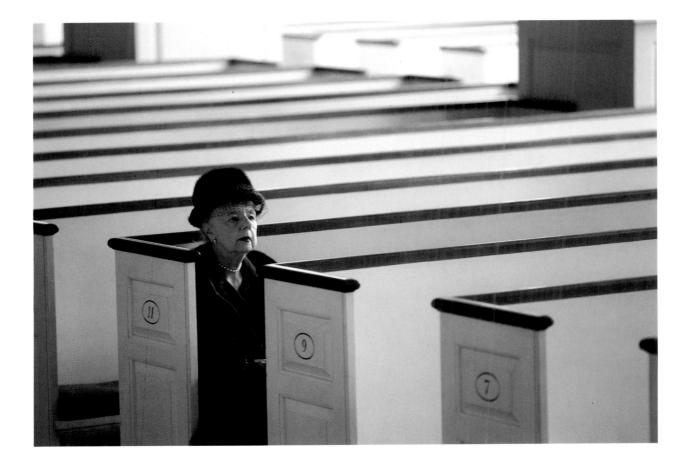

Meditation in Memorial Church

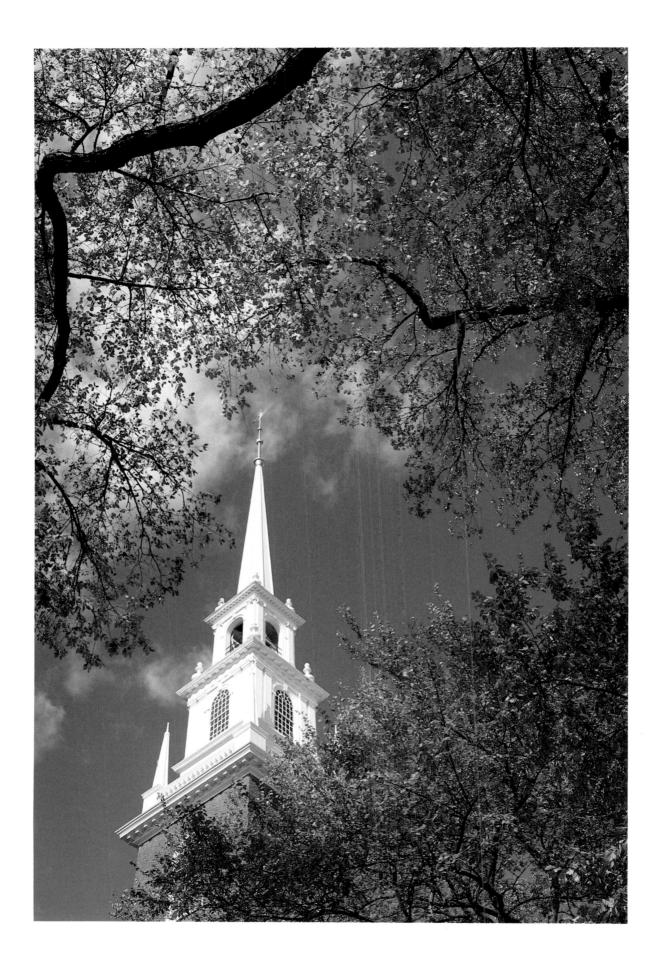

Memorial Church celebrates fall

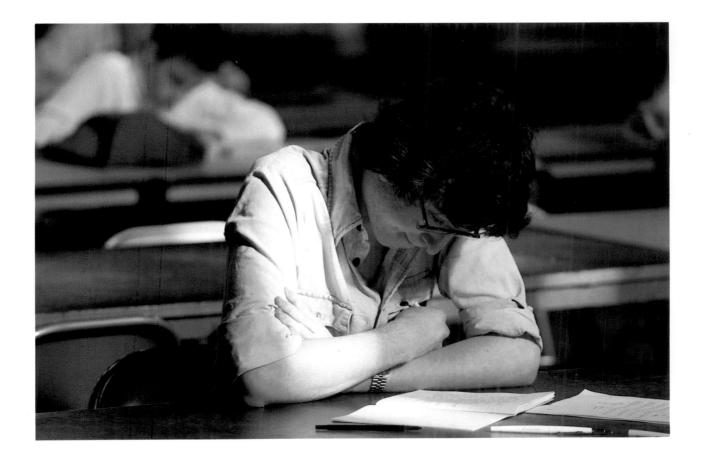

Sunlit exam at Memorial Hall

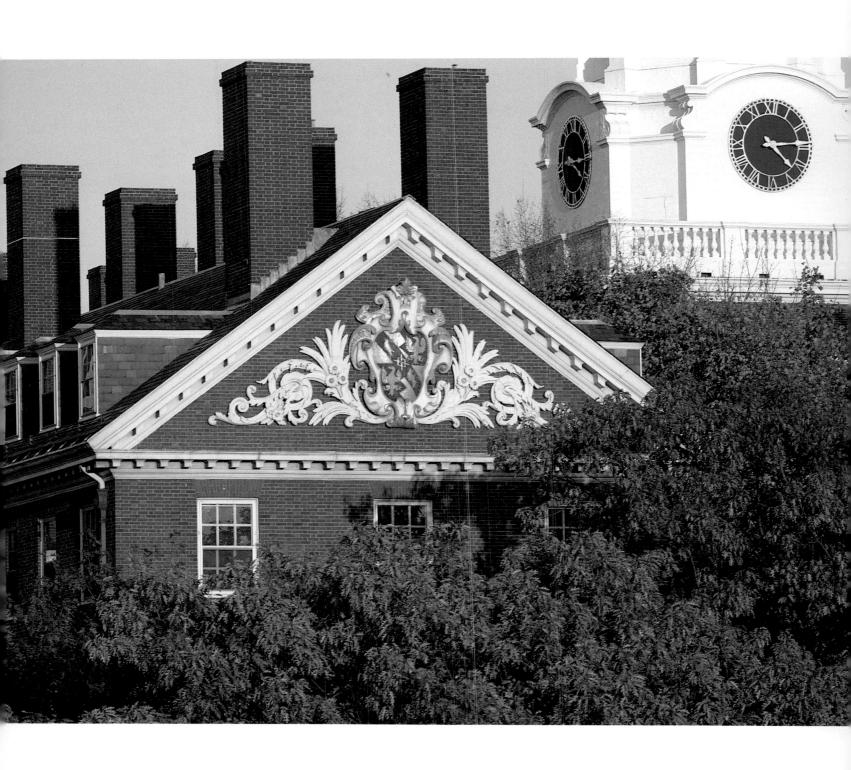

Dunster House, Autumn

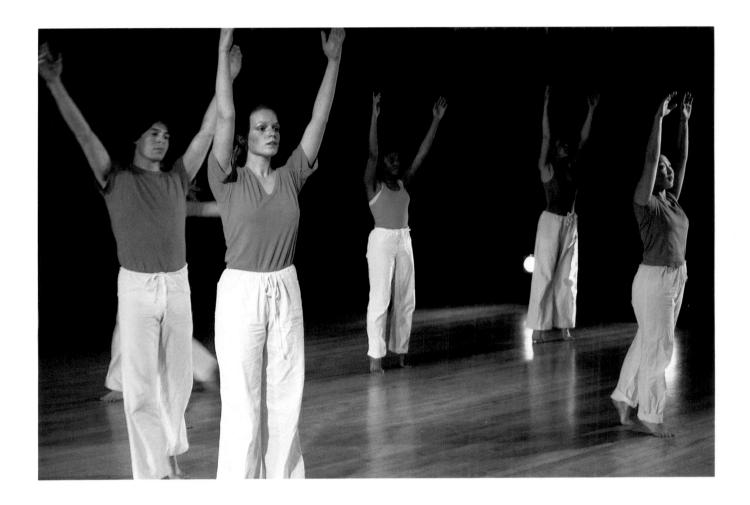

Modern dance, Freshman Union

Sanders Theater

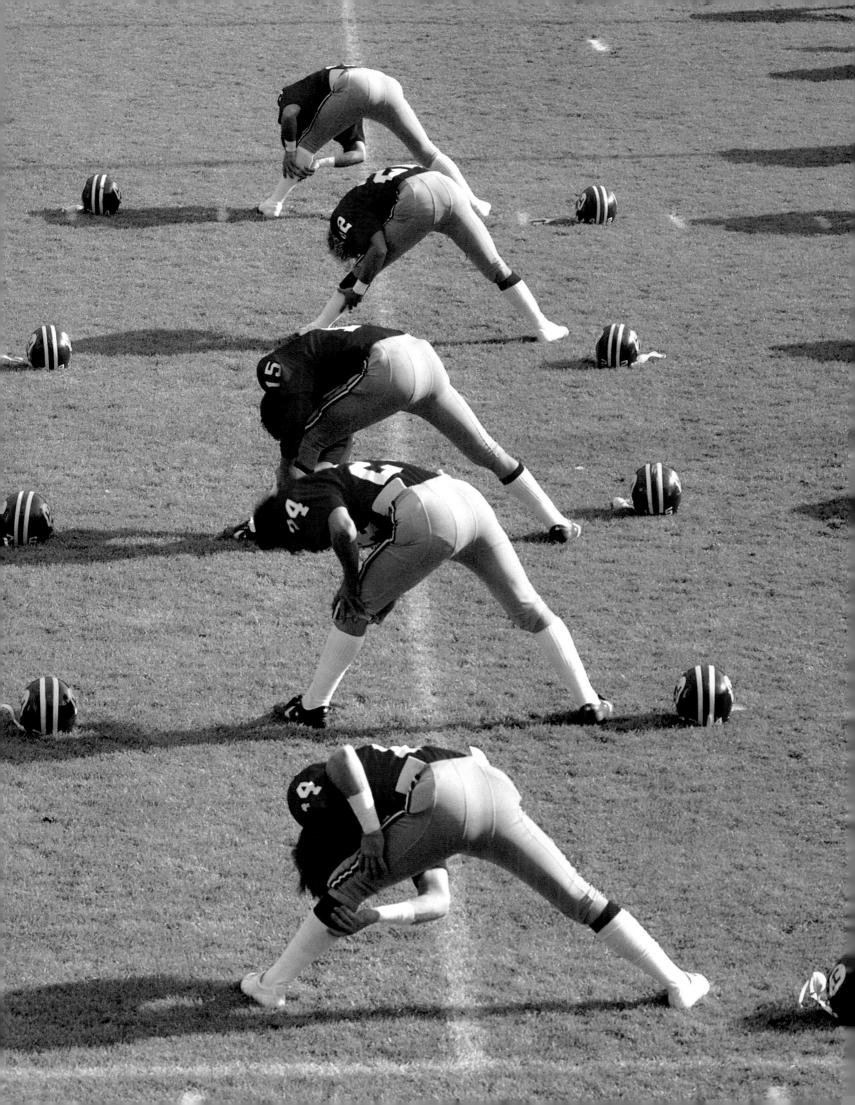

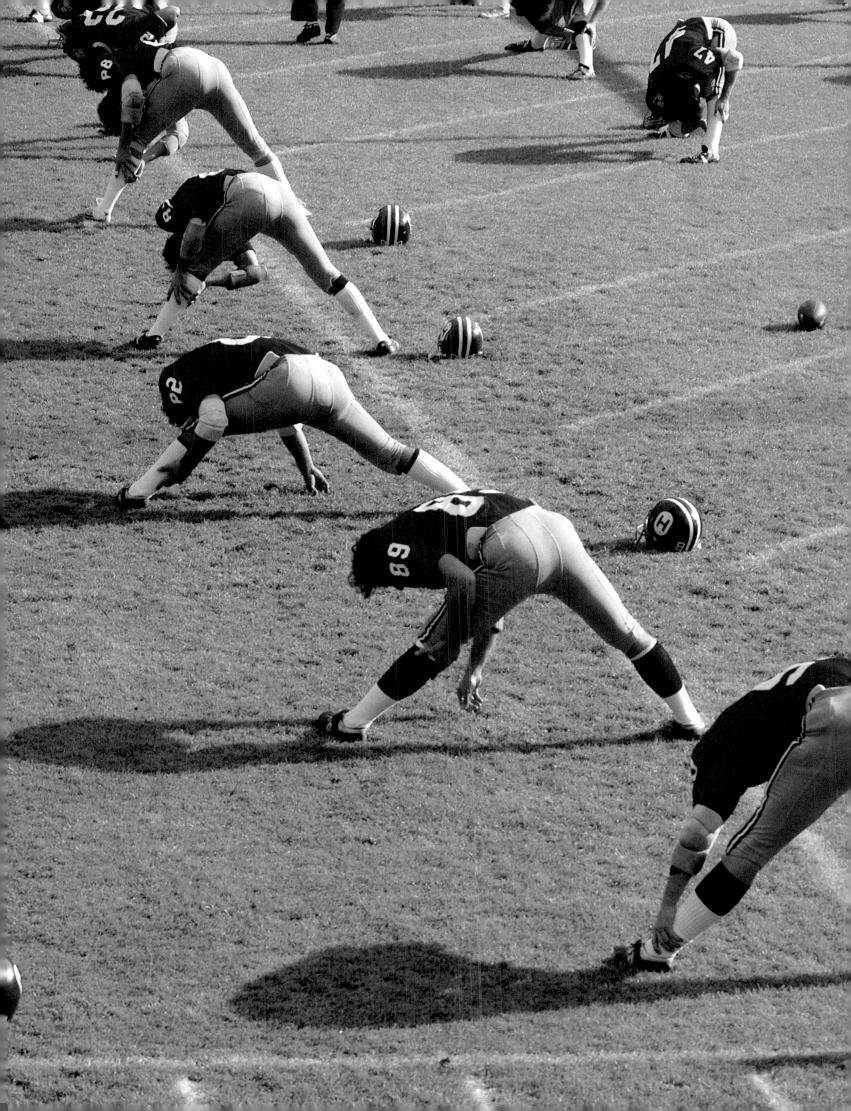

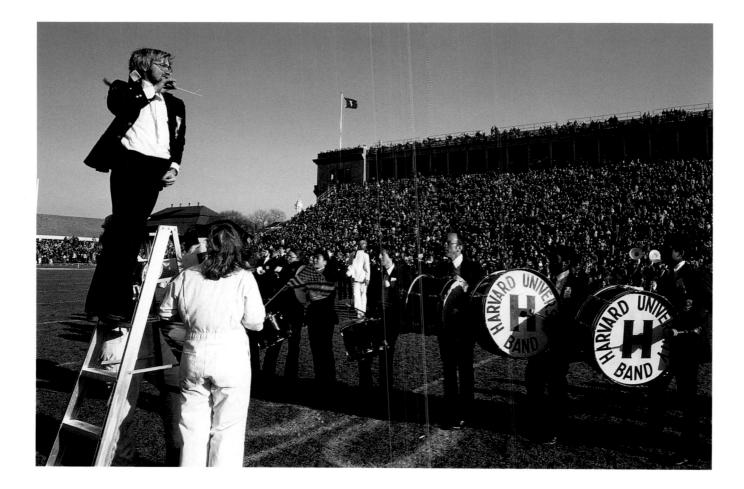

Harvard - Yale Game

Victory music

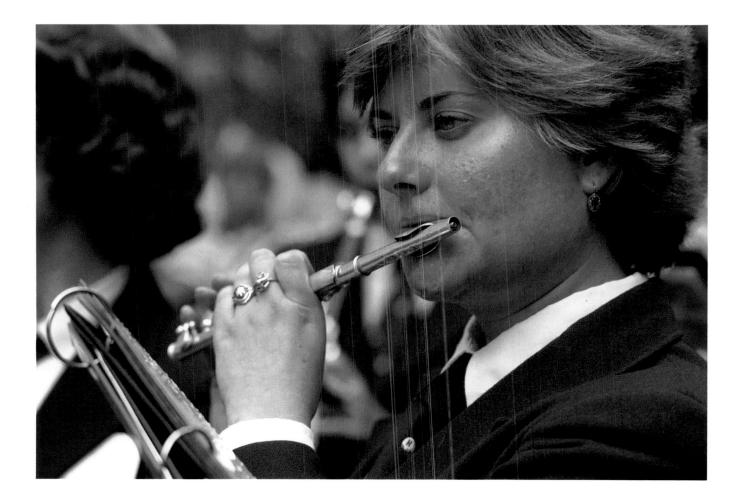

Piccolo player, Harvard Band

Gateway to Soldiers Field

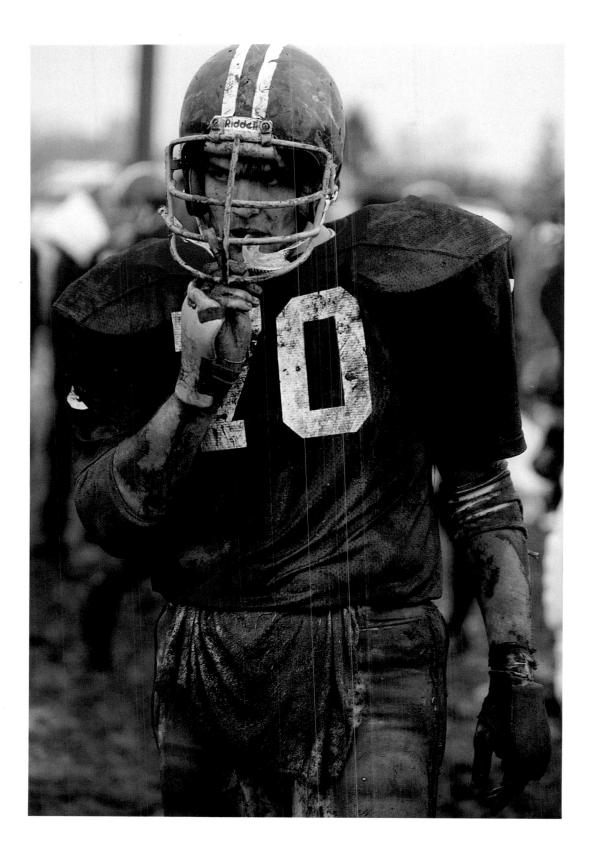

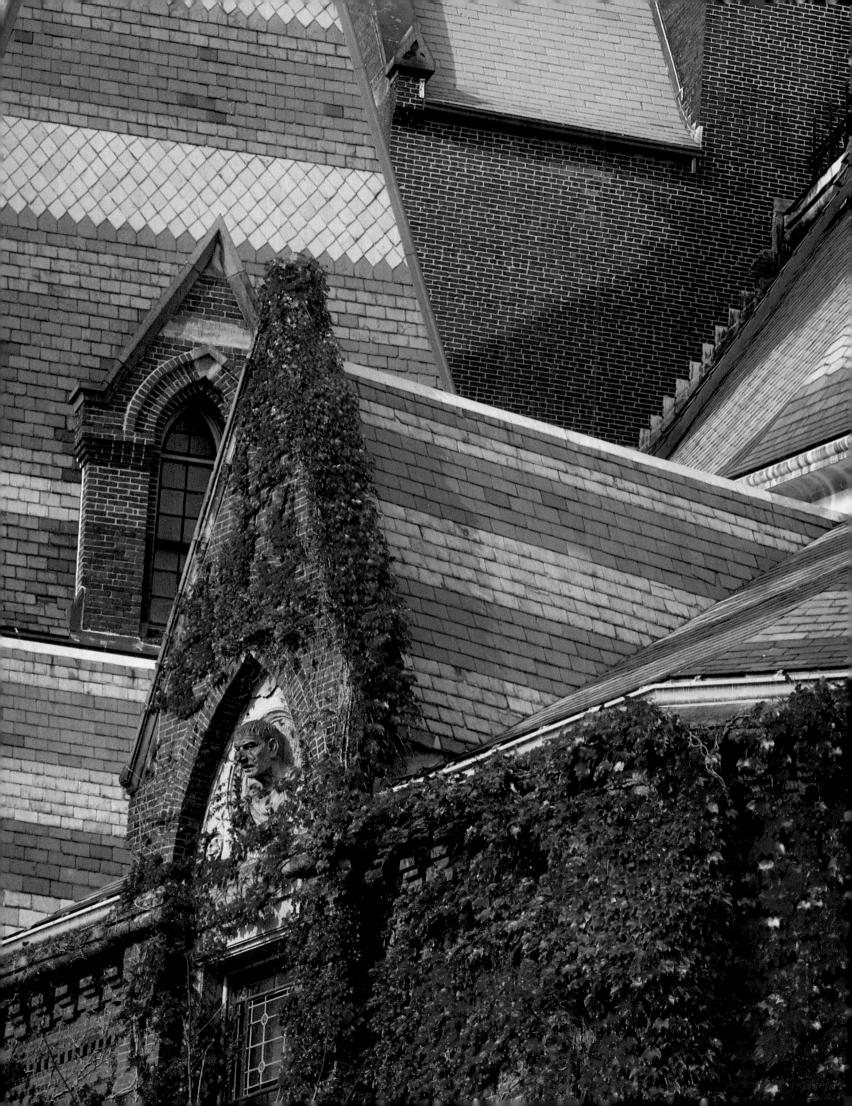

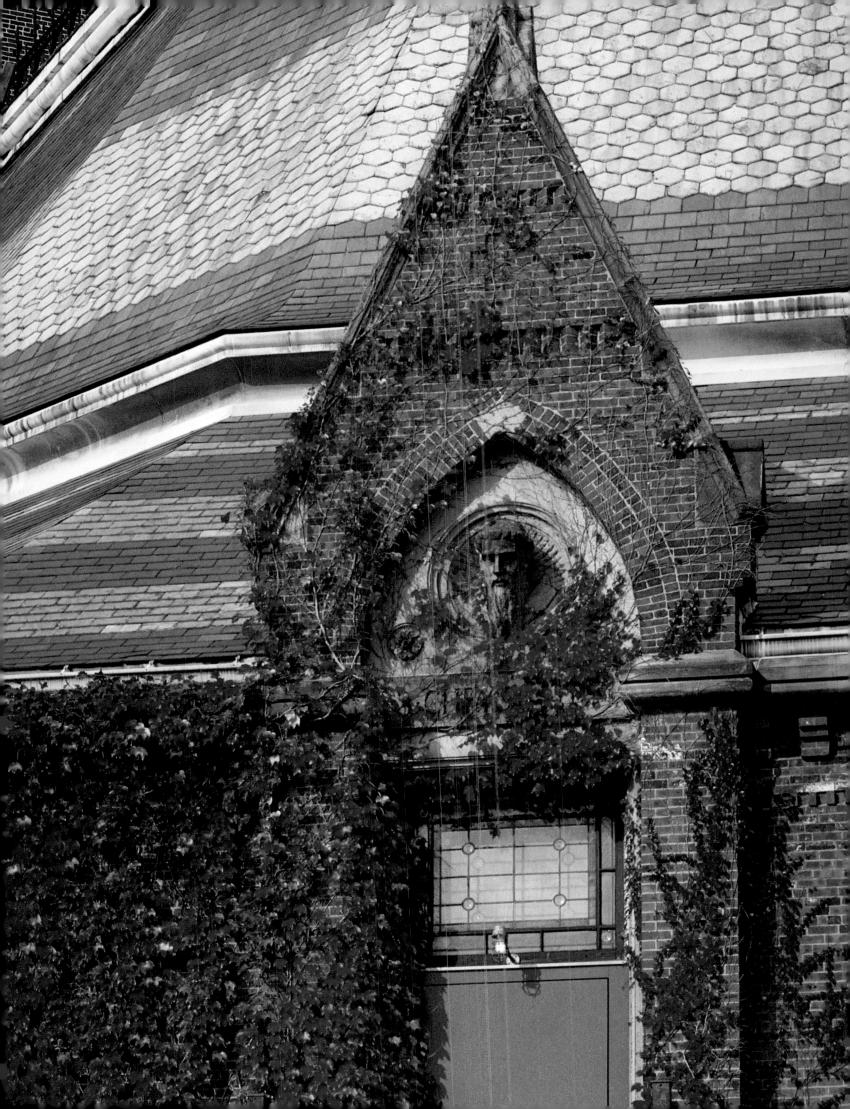

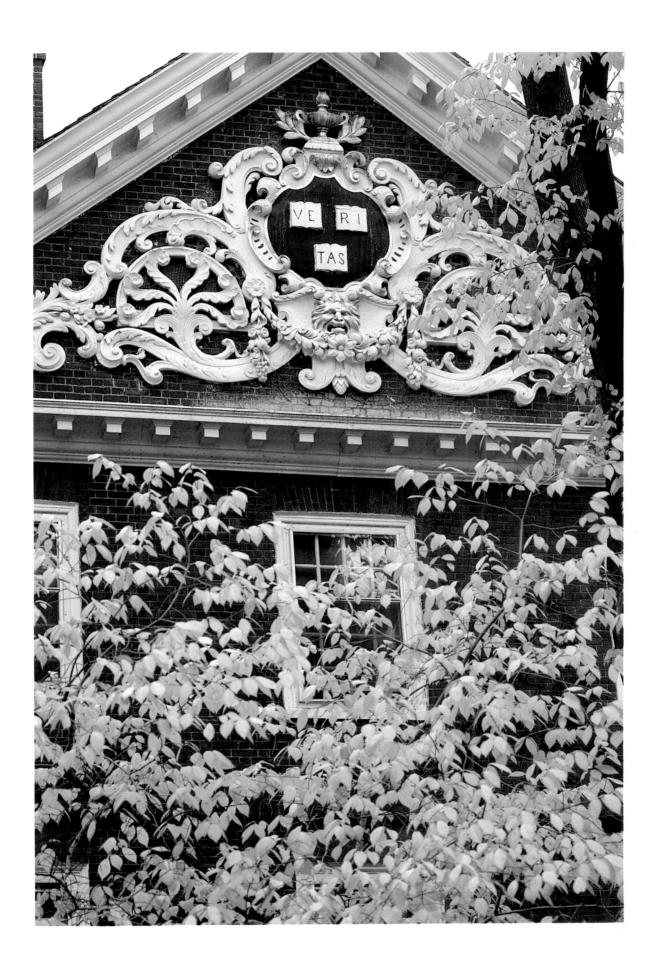

Lowell House

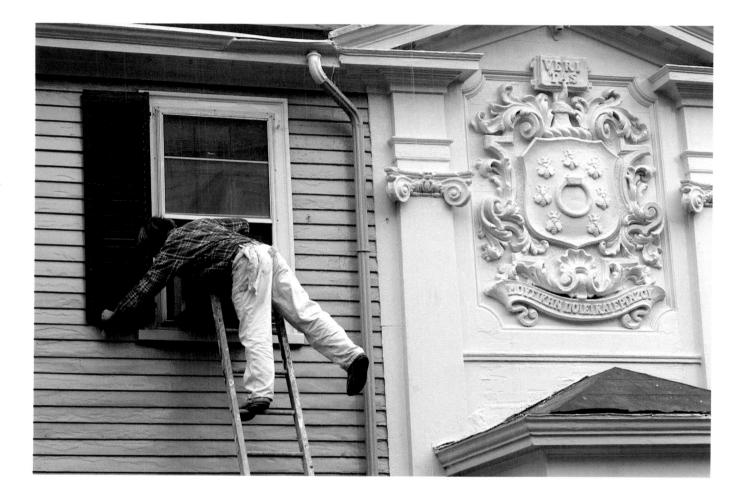

Signet Society

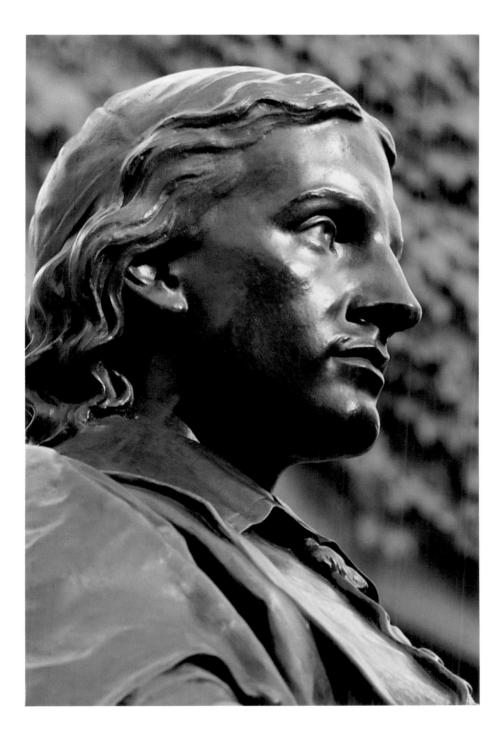

John Harvard, by Daniel Chester French

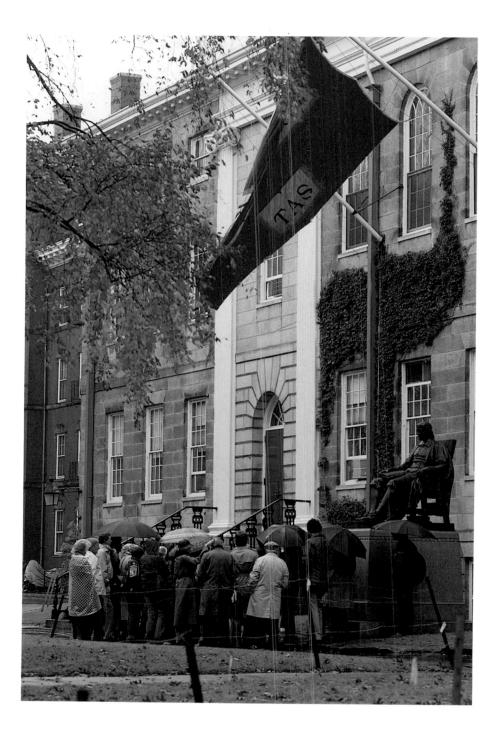

A tour of the Yard

Hasty Pudding Club

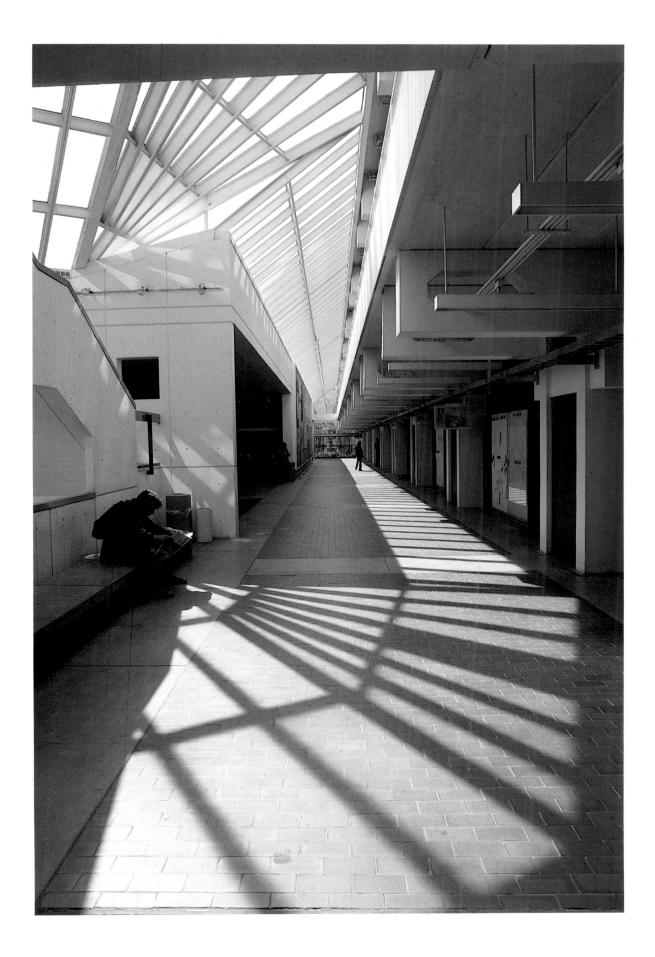

Science Center

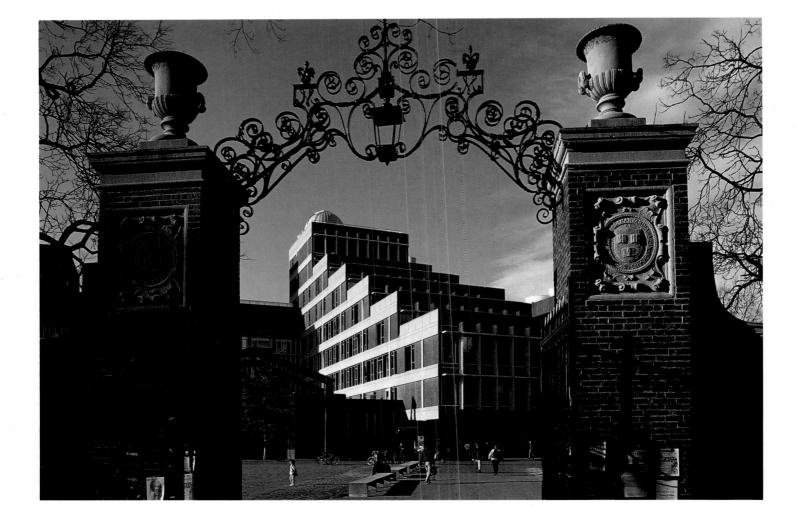

Meyer Gate, Science Center

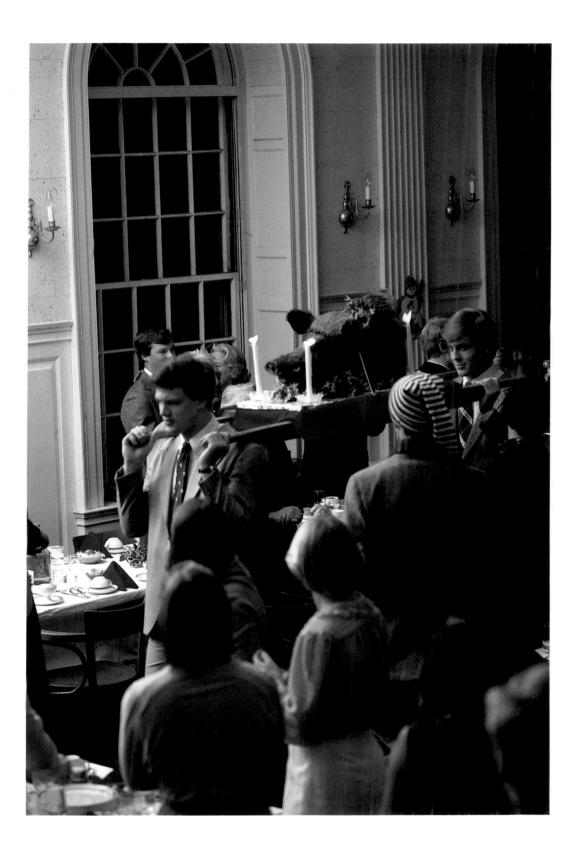

Christmas at Kirkland House

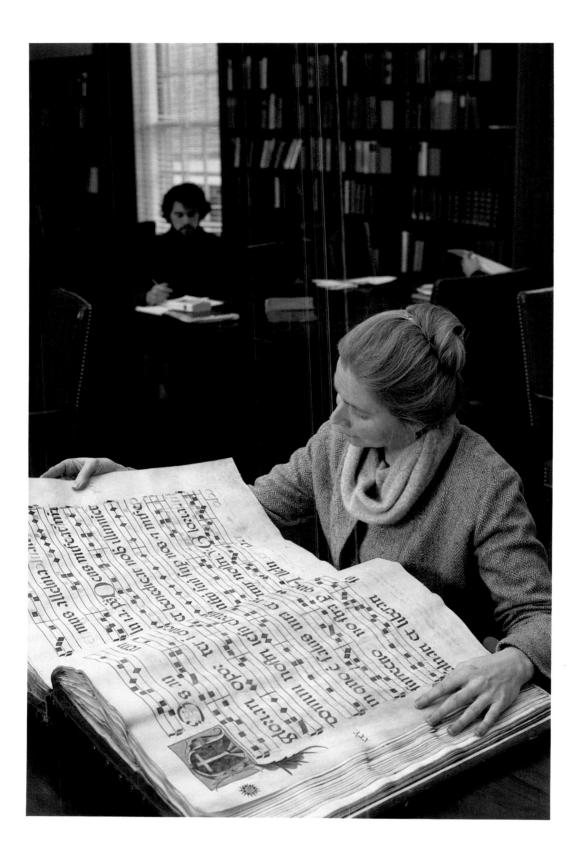

Medieval sheet music, Houghton Library

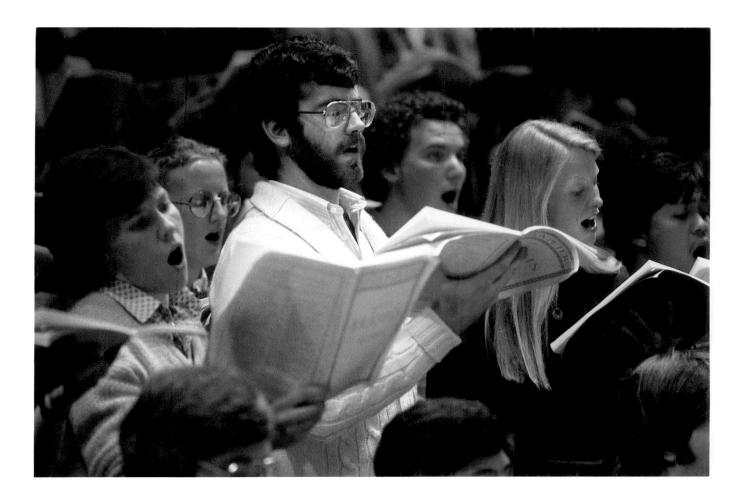

Chorus rehearses Brahms' *Requiem* at Sanders Theater

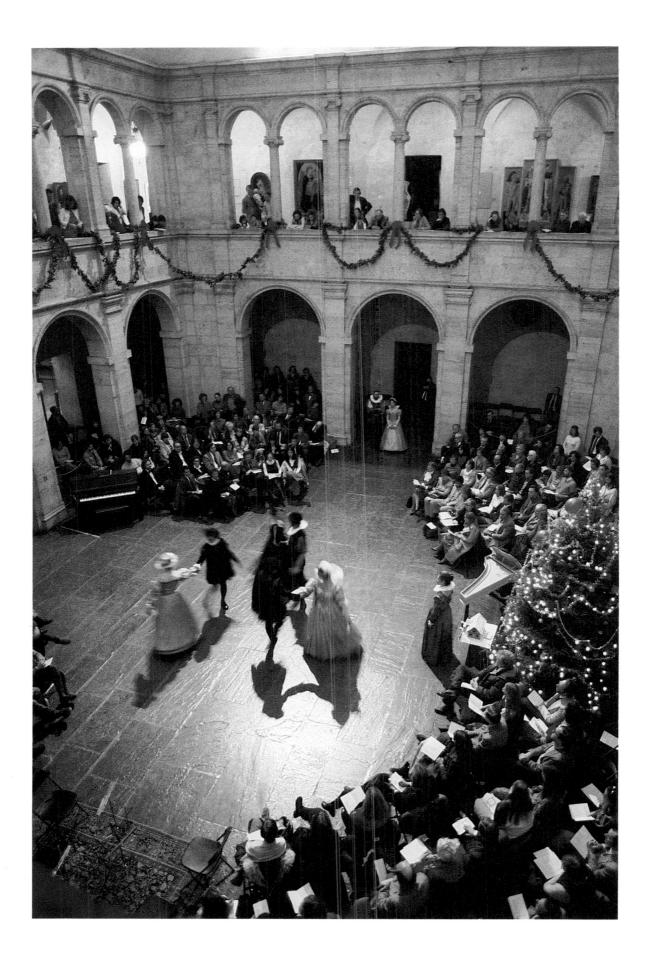

Elizabethan dancers celebrate Christmas, Fogg Museum Overleaf: News center at The Science Center

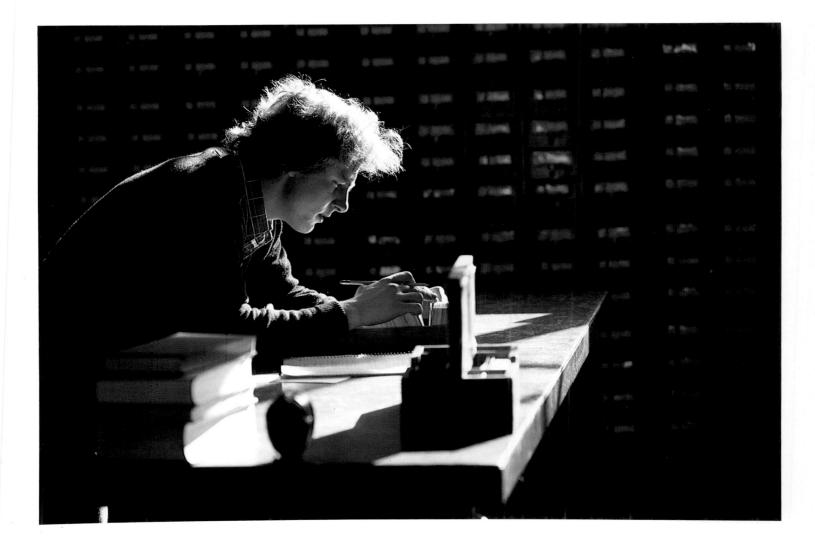

Research at Widener Library

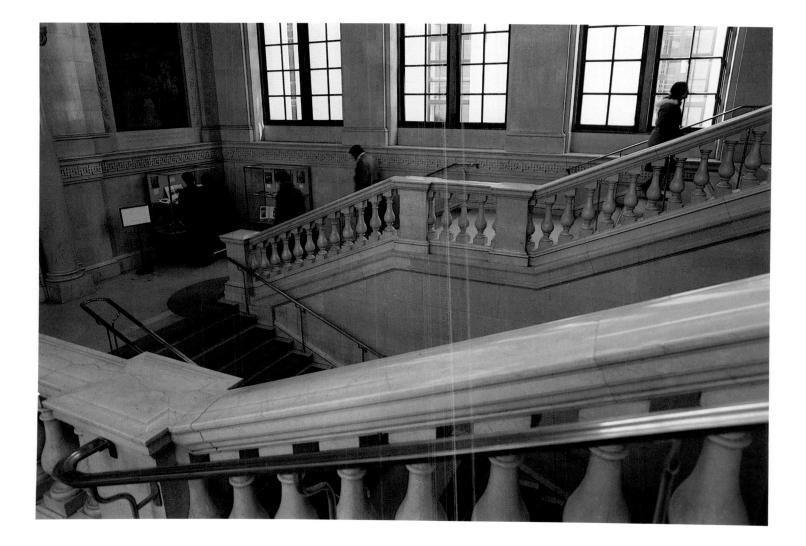

Grand staircase, Widener Library

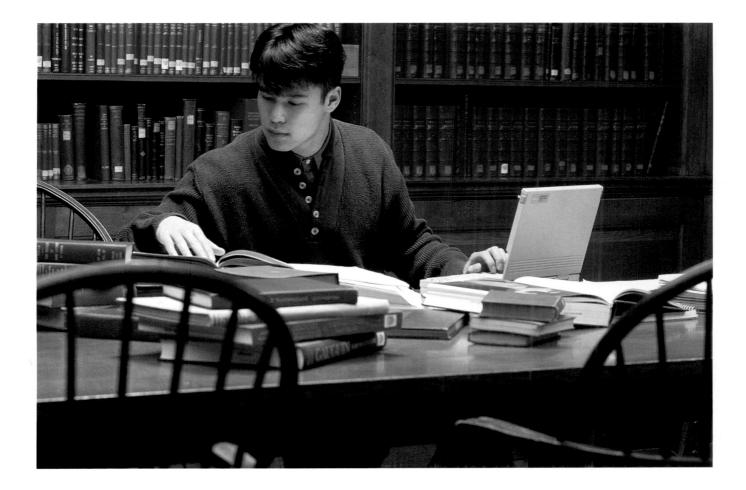

Dunster House library

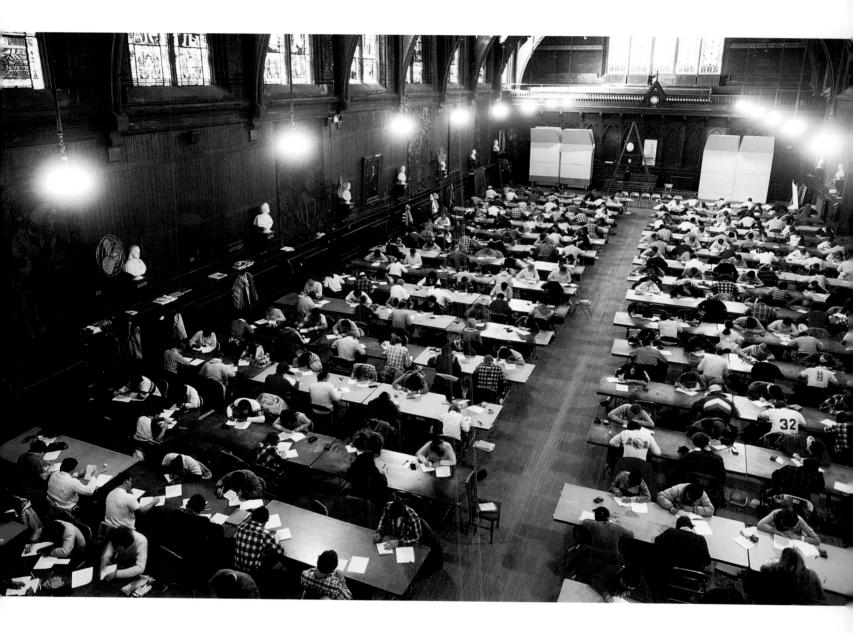

Winter exams, Memorial Hall

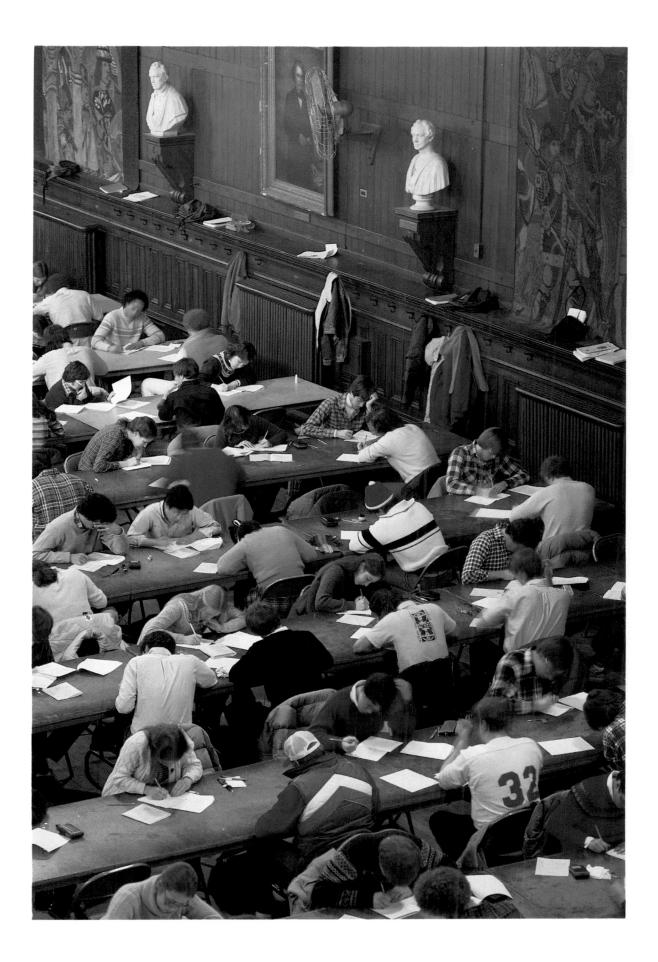

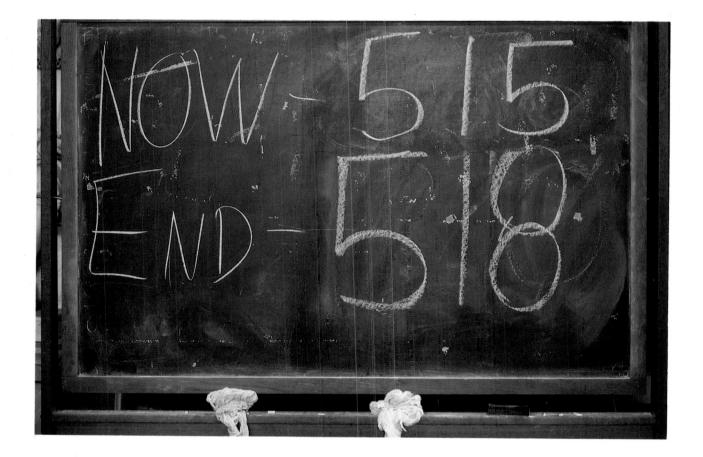

Racing the exam clock at Memorial Hall

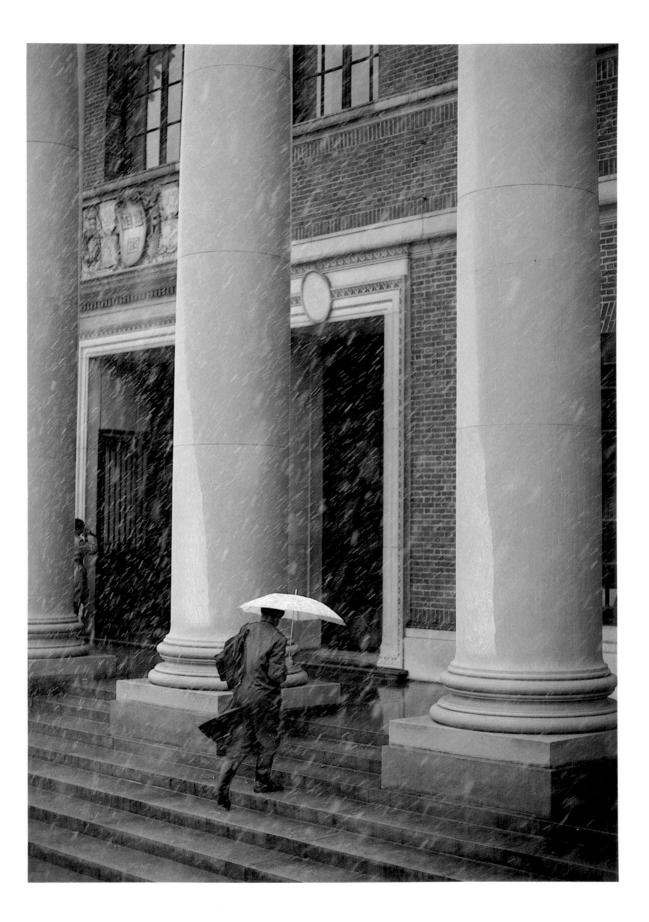

Widener Library snowfall

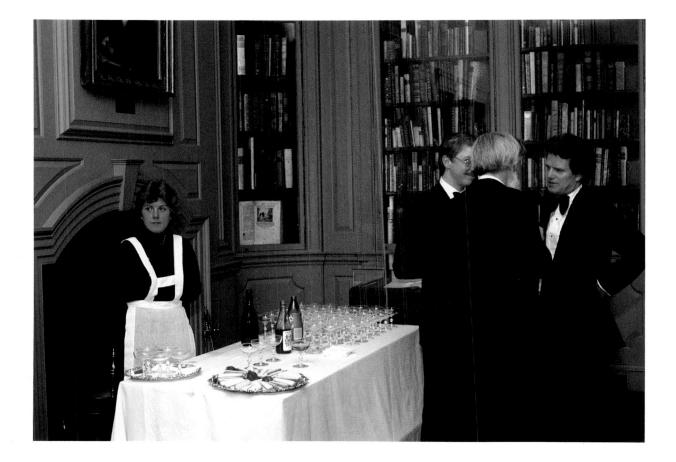

Black tie opening at Houghton Library

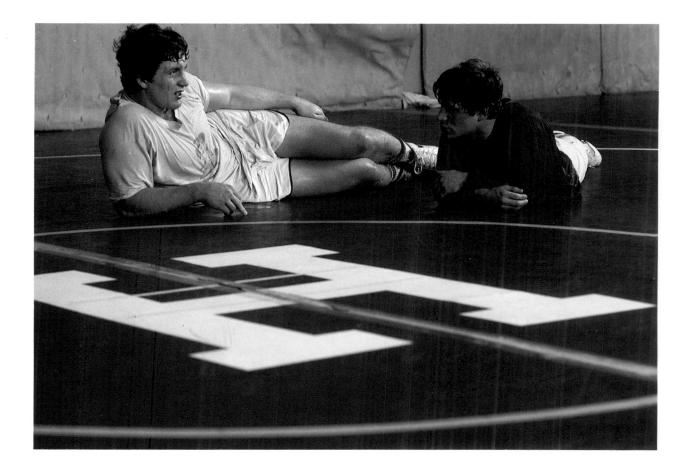

Wrestlers take ten, Indoor Athletic Building

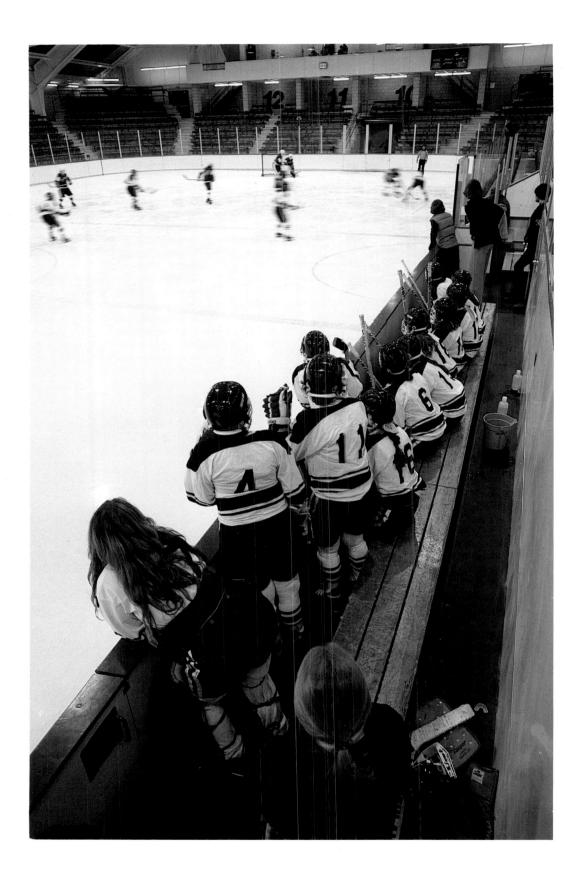

Radcliffe takes the ice at Bright Hockey Center

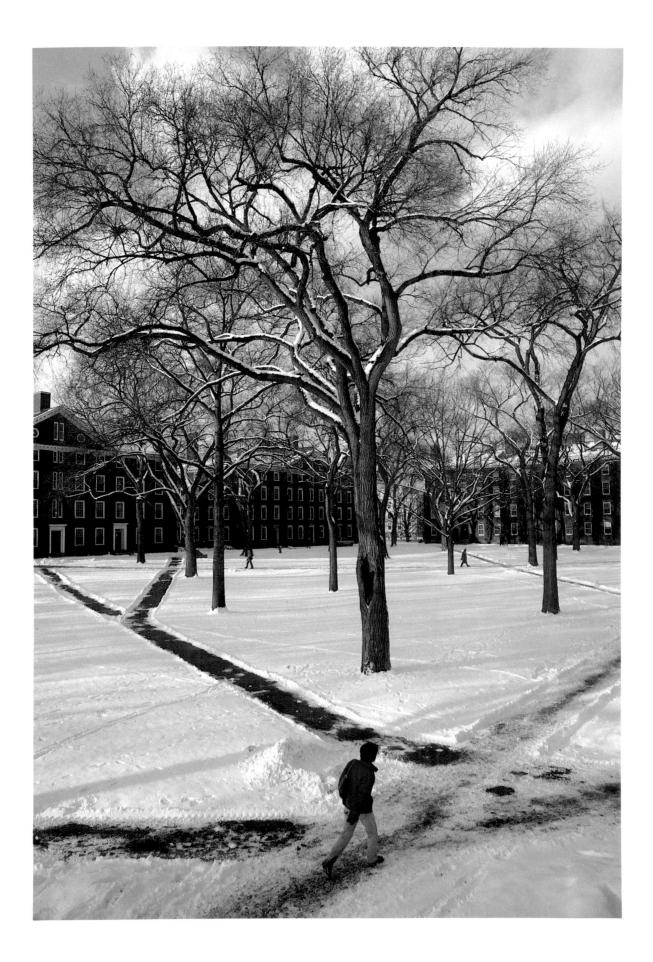

The Yard – Hollis, Stoughton and Holworthy Halls

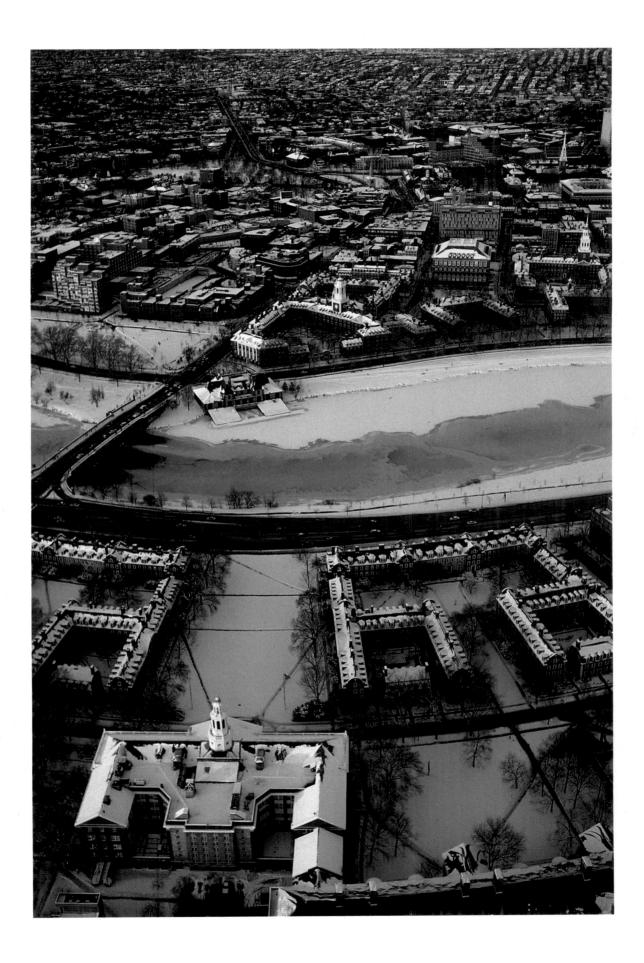

Business School, Charles River

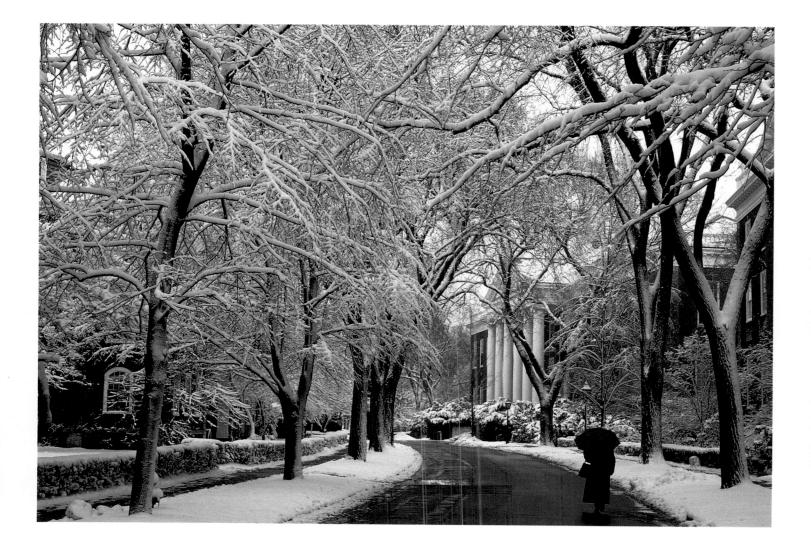

Business School, Baker Library

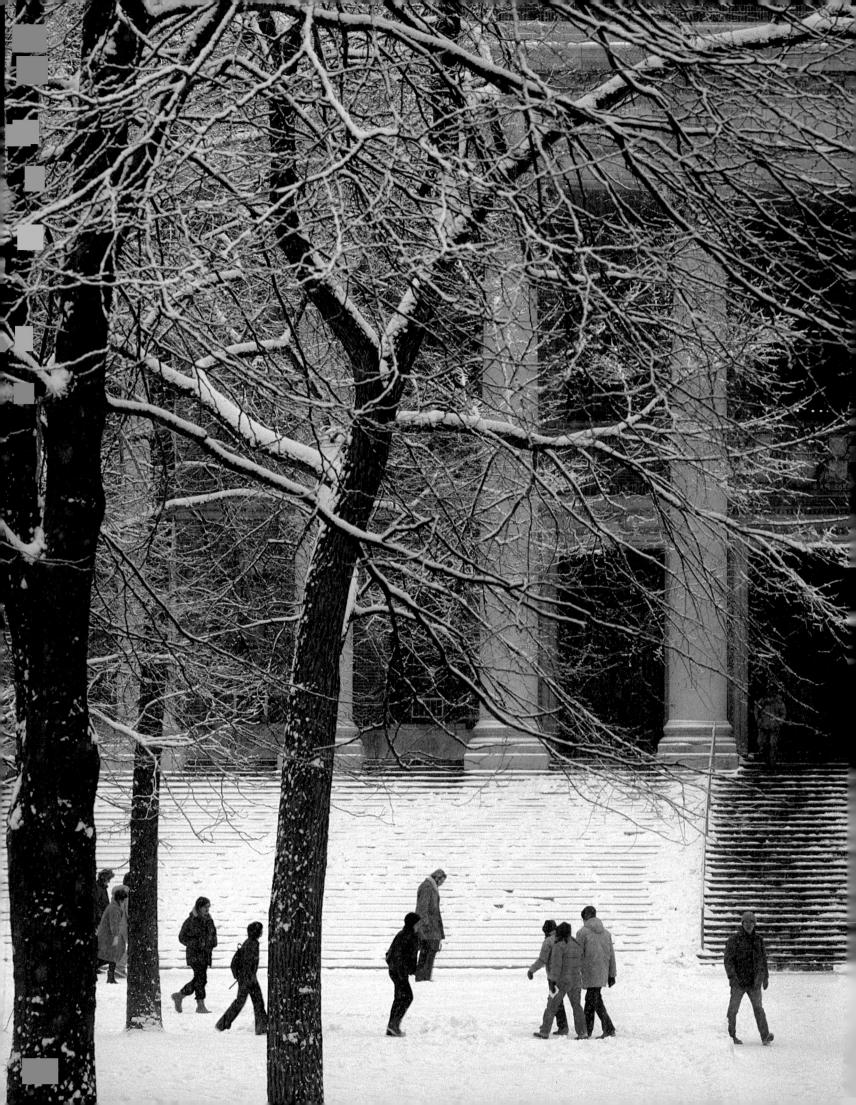

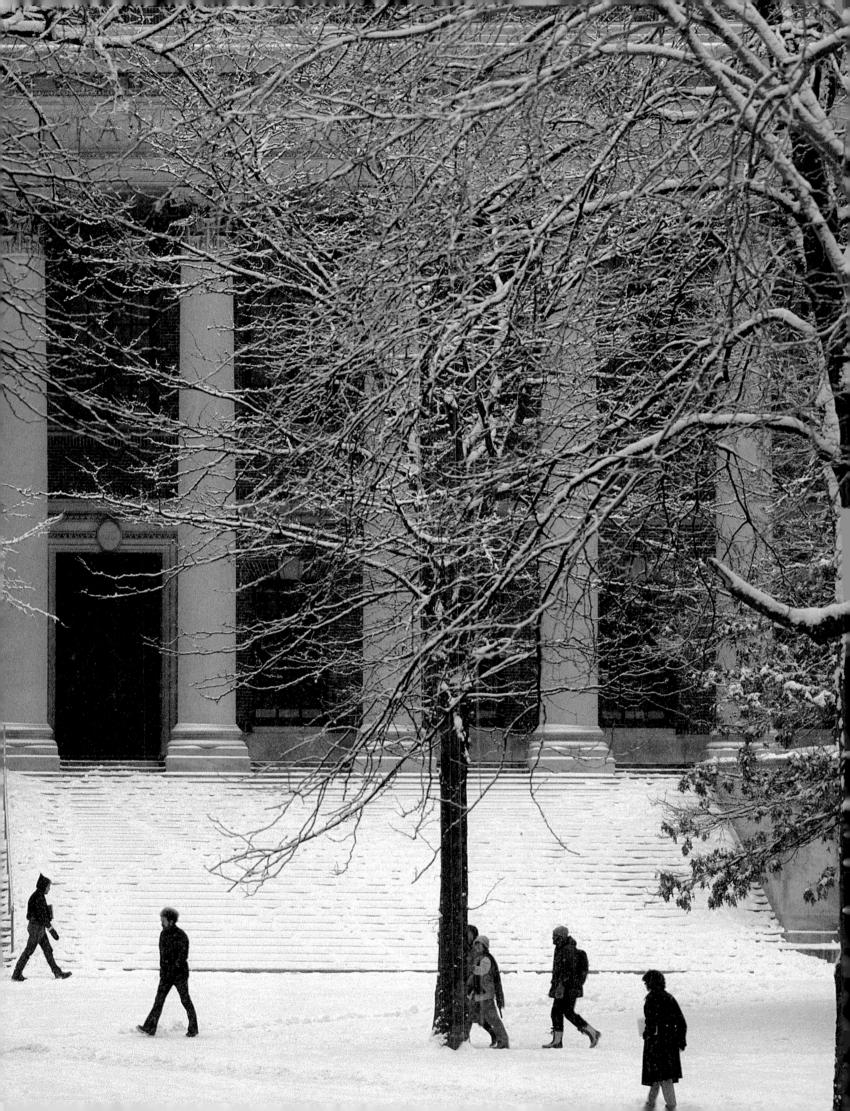

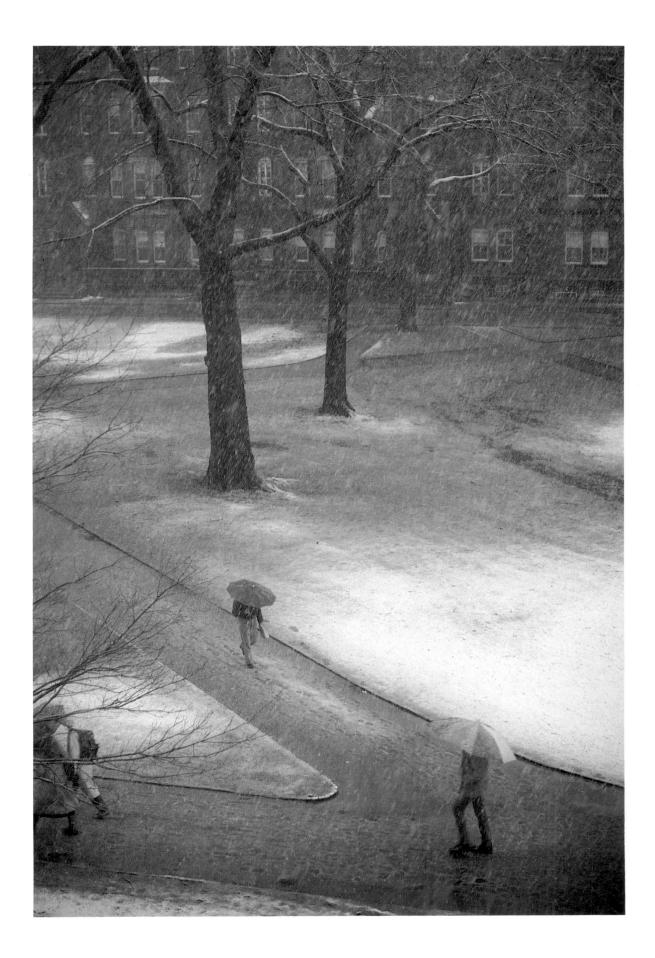

Harvard Yard, Matthews Hall

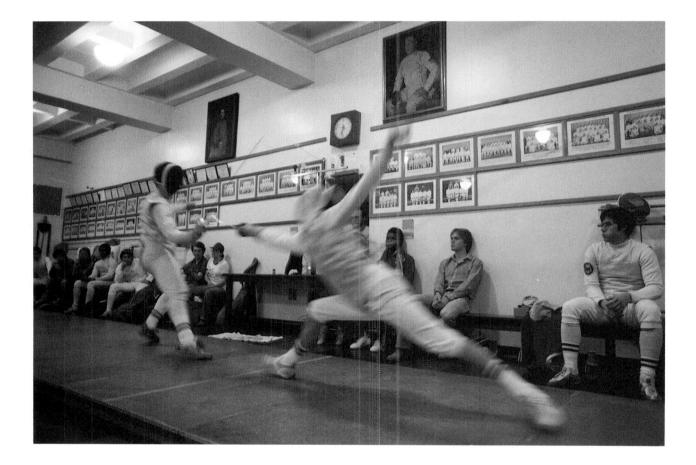

Fencing, Indoor Athletic Building

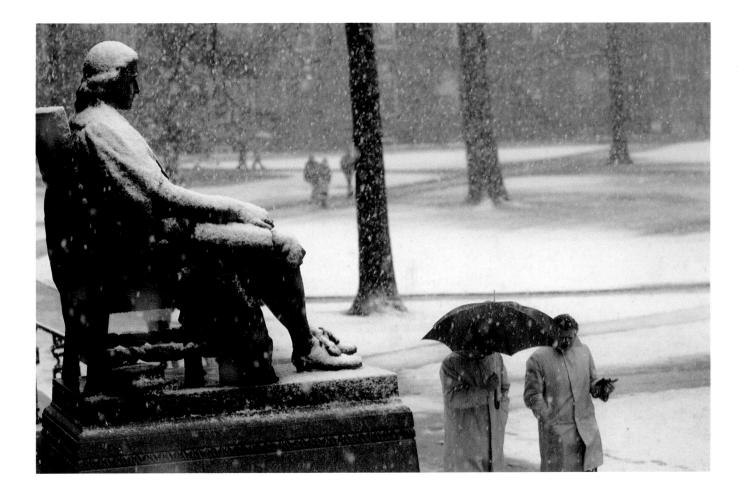

John Harvard

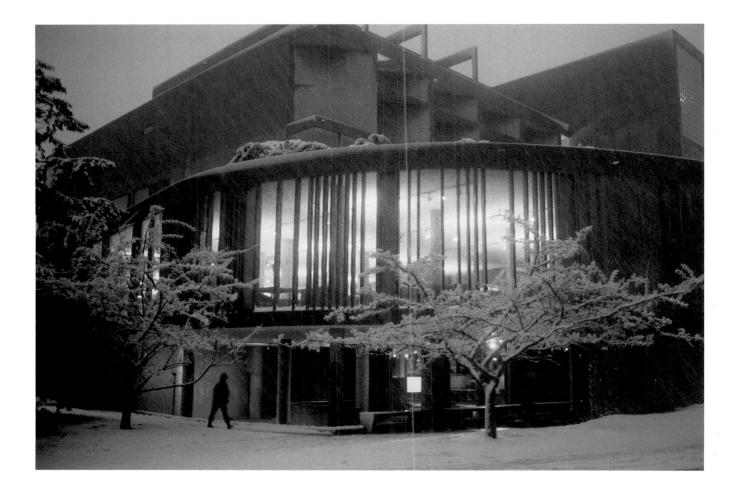

Carpenter Center

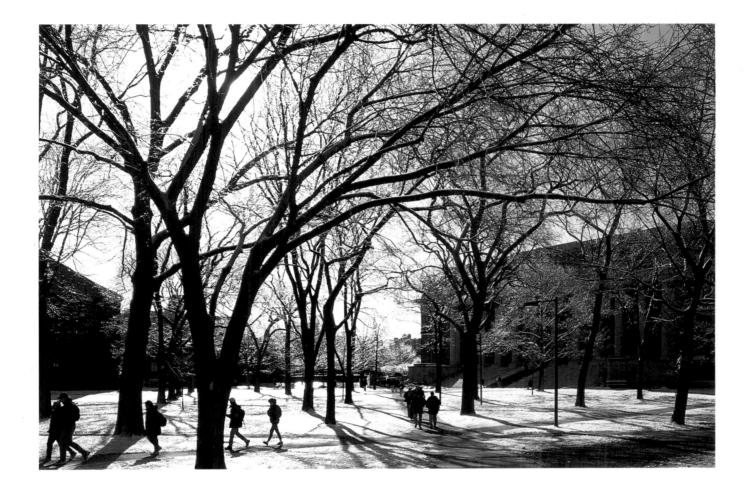

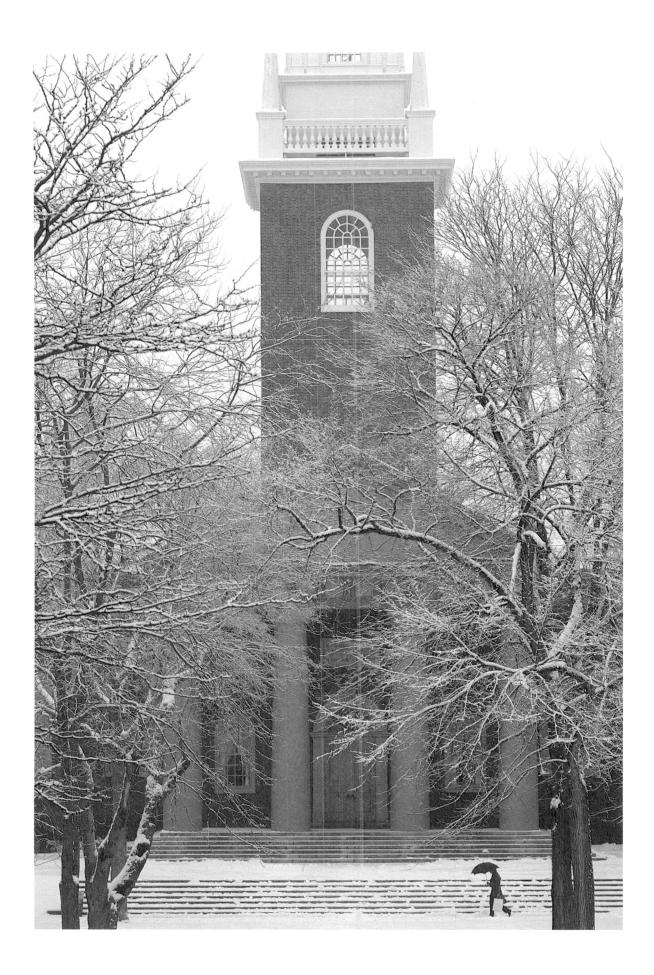

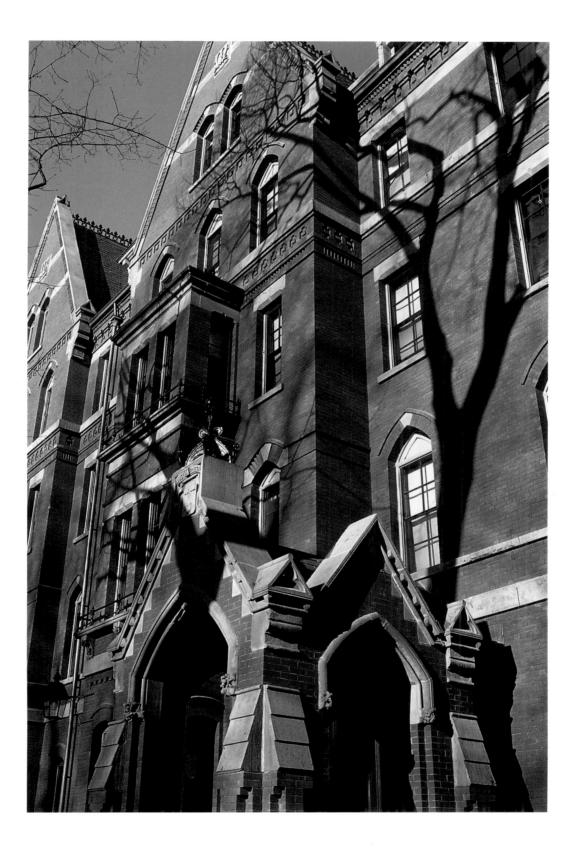

Matthews Hall

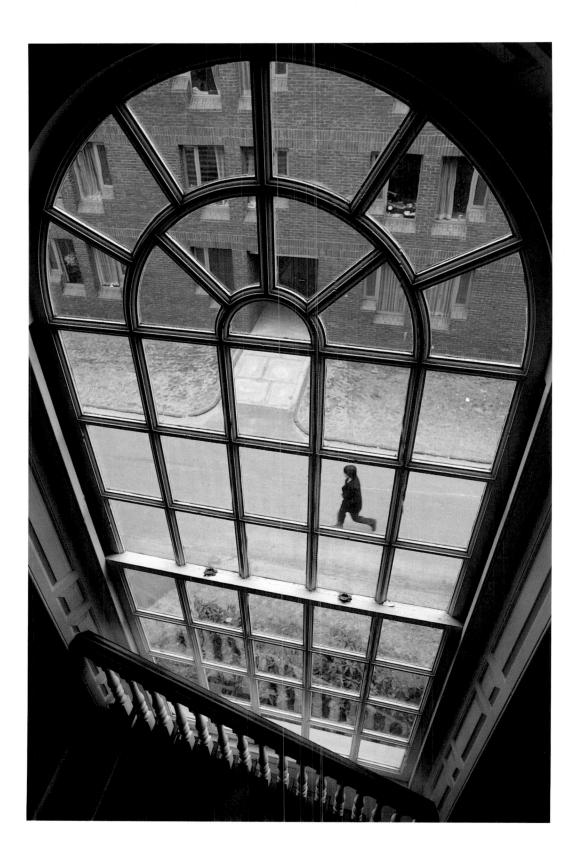

Memorial Church and Canaday Hall

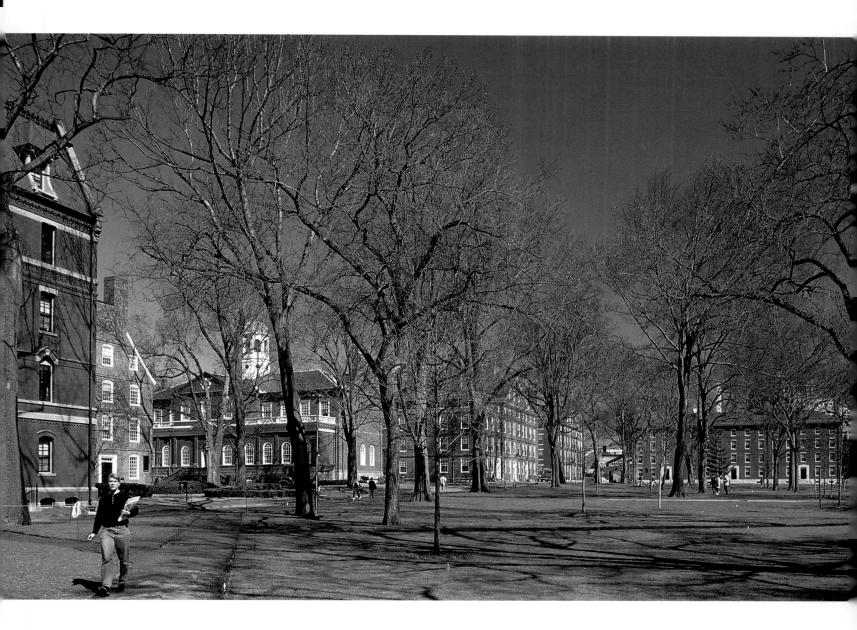

Harvard Yard, Spring

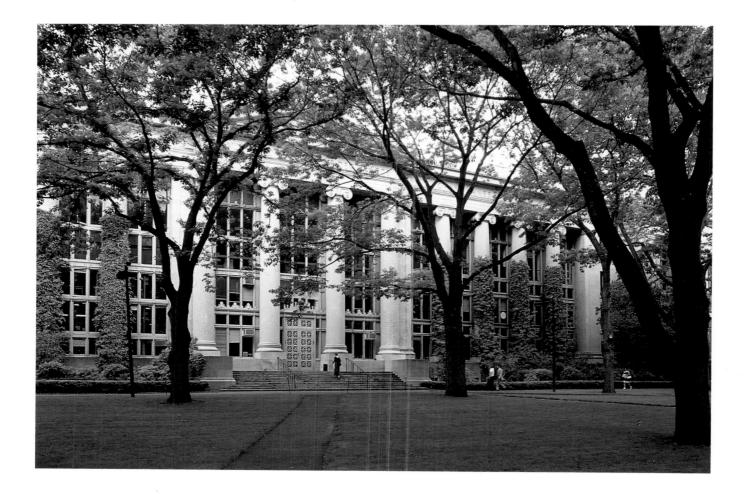

Langdell Hall, Law School

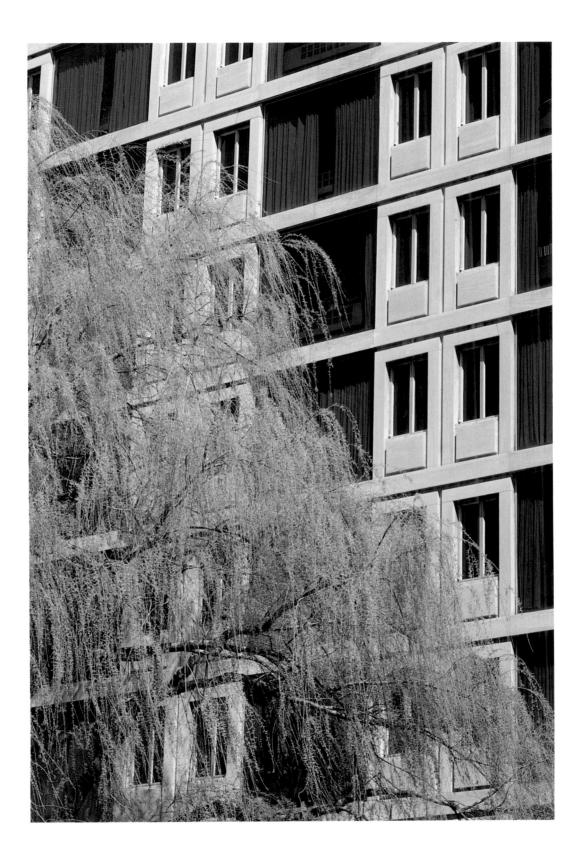

Willows at Leverett Towers

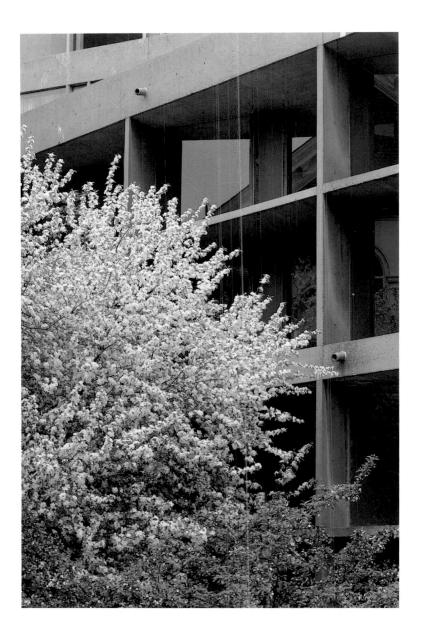

The cherry trees of Carpenter Center

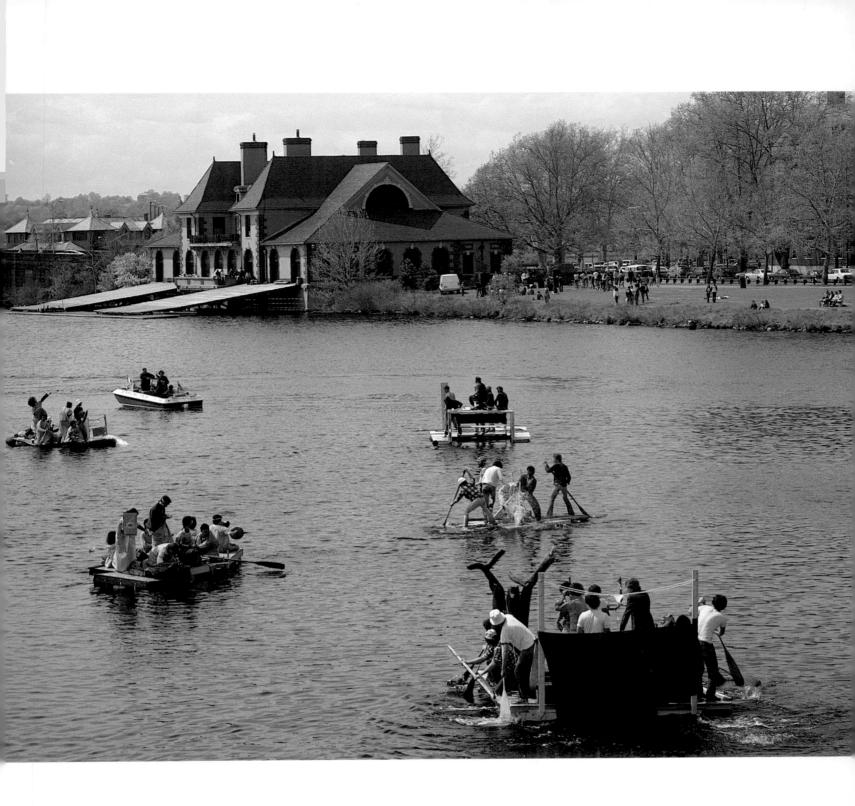

The Adams House boat race

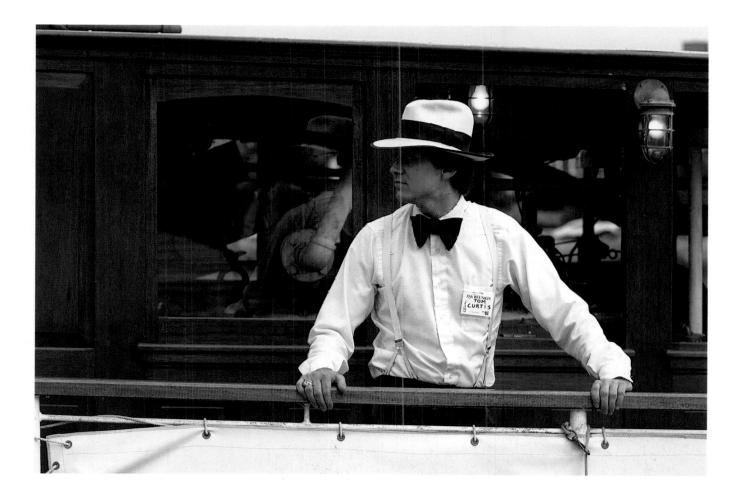

Reunion steward at the rail of a Charles River steamer

John F. Kennedy Park

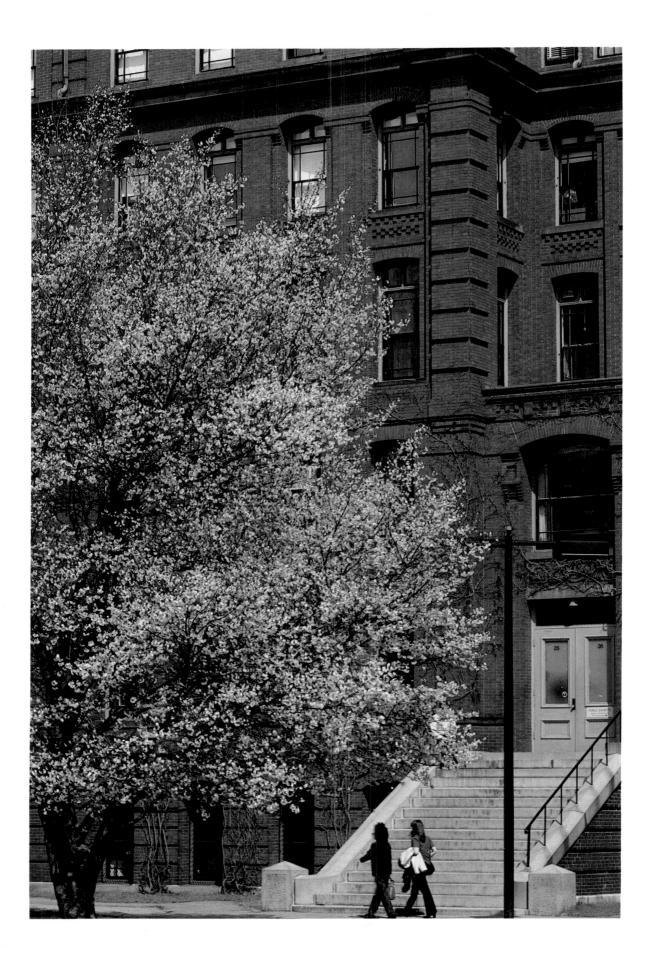

University Museum

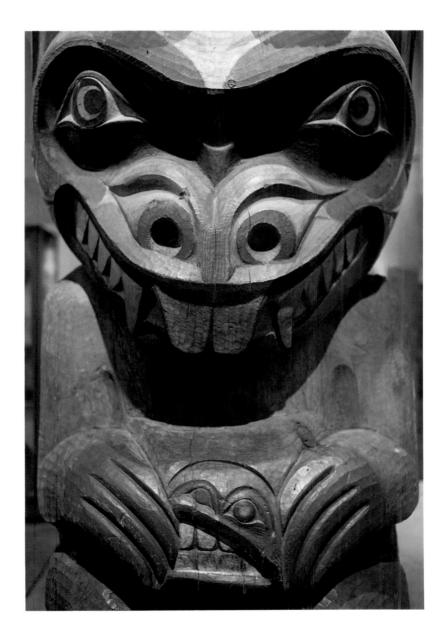

Kwakiutl house post, Peabody Museum

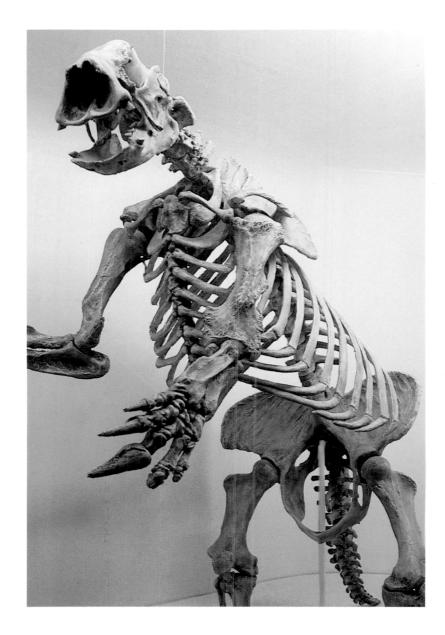

Skeletal giant sloth, Museum of Comparative Zoology Overleaf: Mill Street facade, Lowell House tower

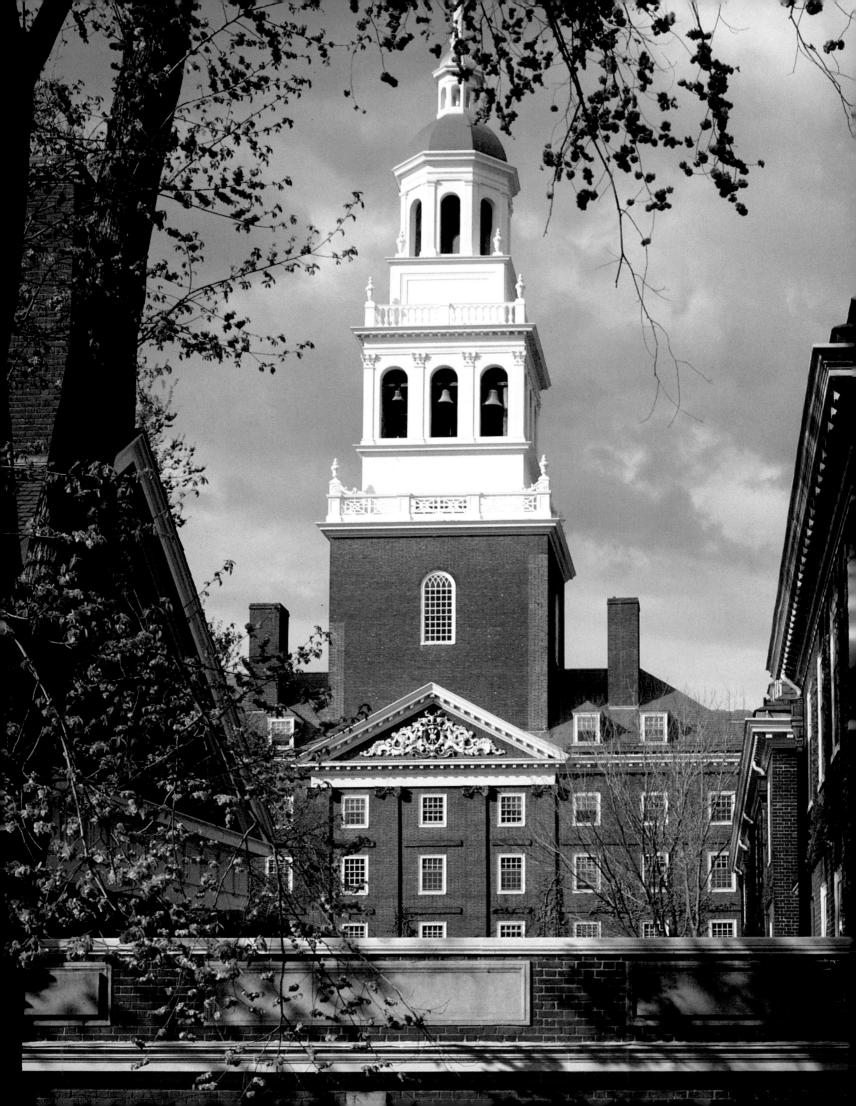

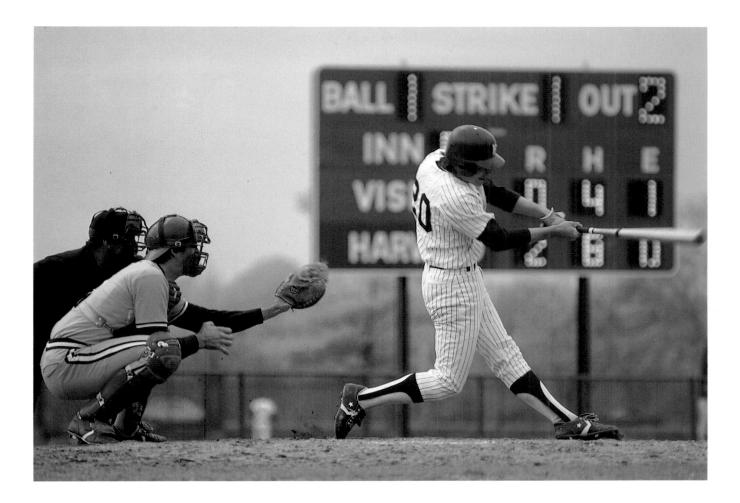

Another drive, another run for Harvard at Soldiers Field

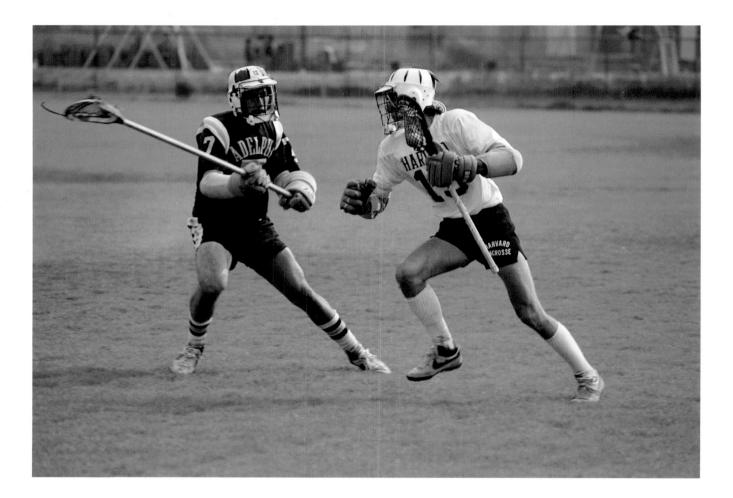

Lacrosse on the Business School Field

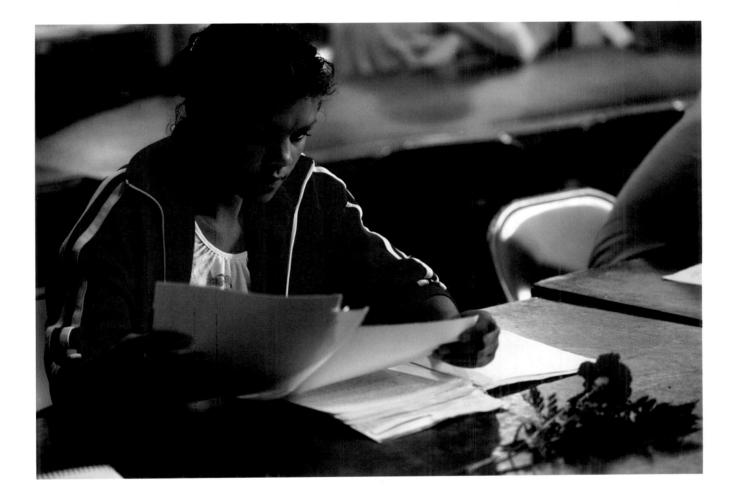

Final exams

Collecting Spanish exams, Emerson 101

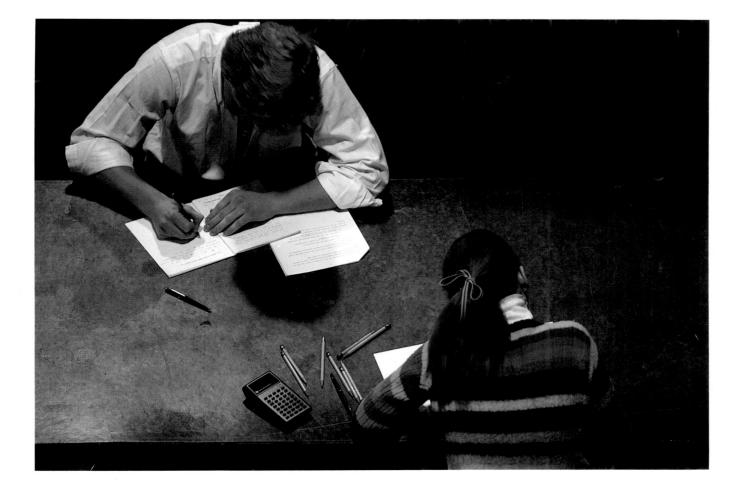

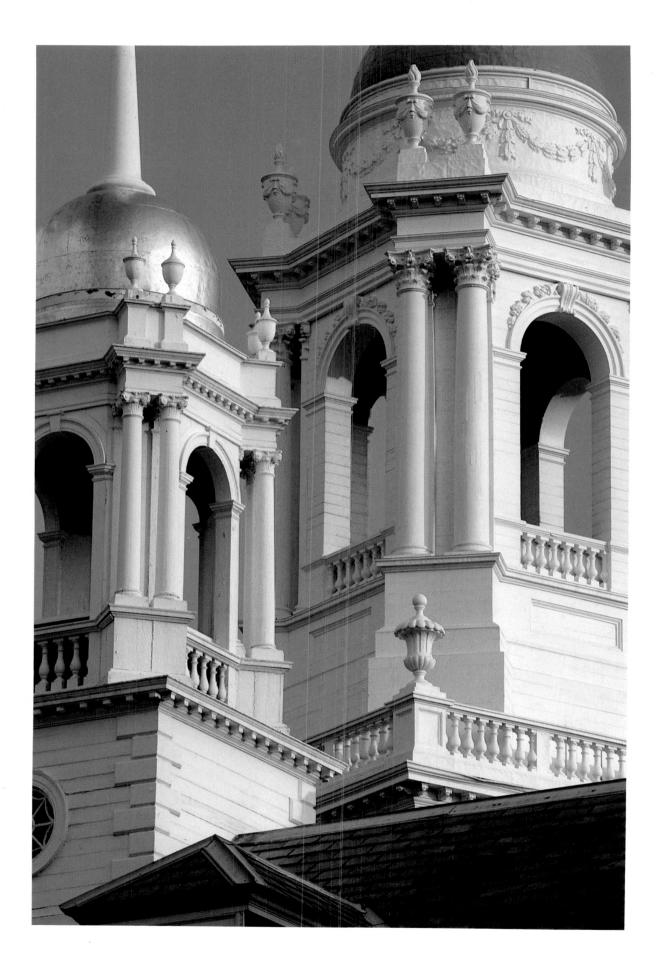

Twilit domes of Kirkland and Eliot towers

The Lampoon

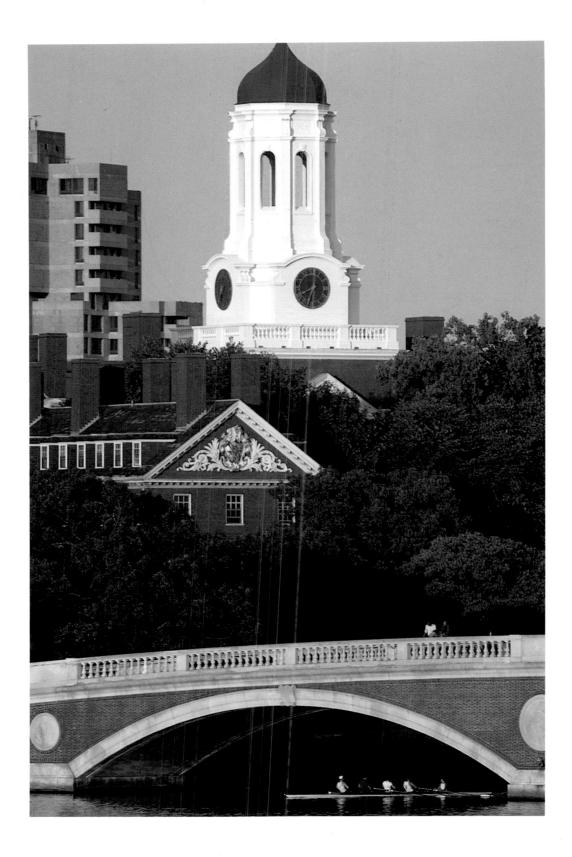

Under Weeks Bridge at dusk

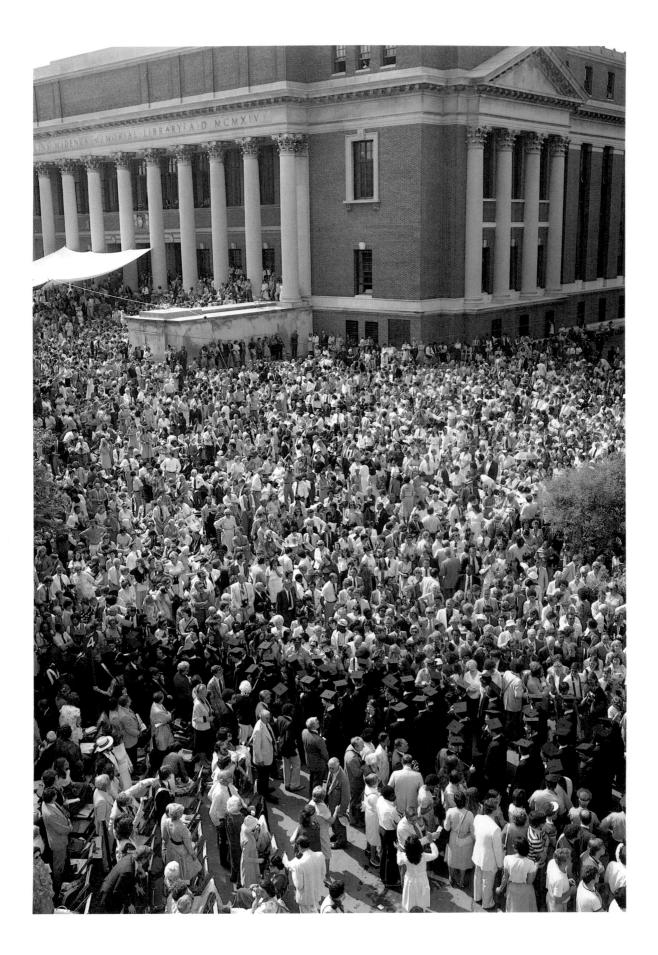

Commencement procession

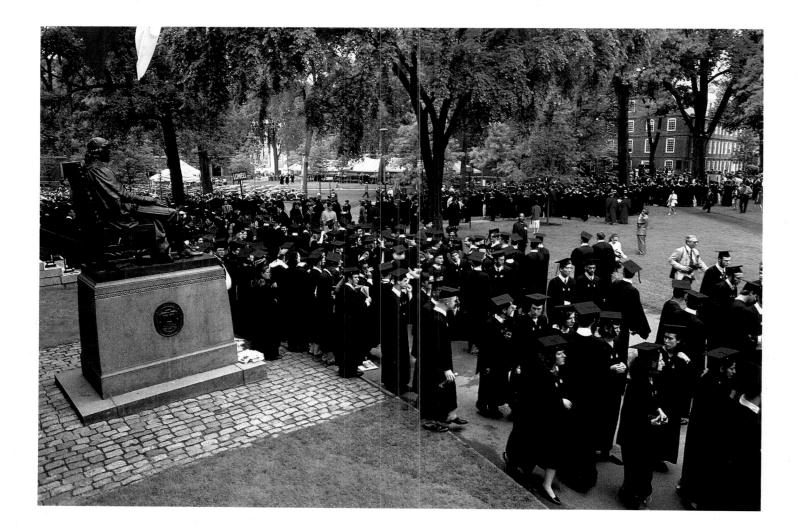

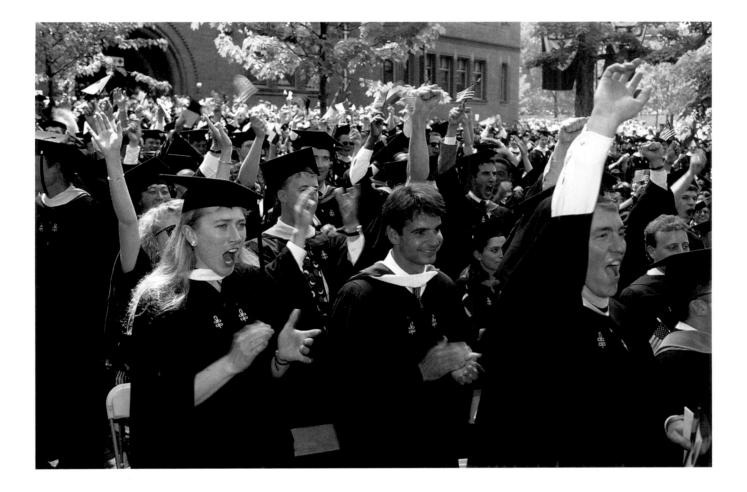

Business School graduates

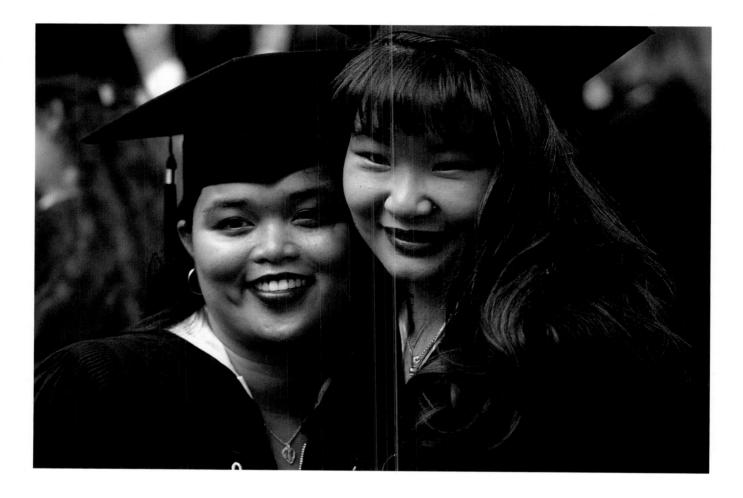

Eliot House graduates

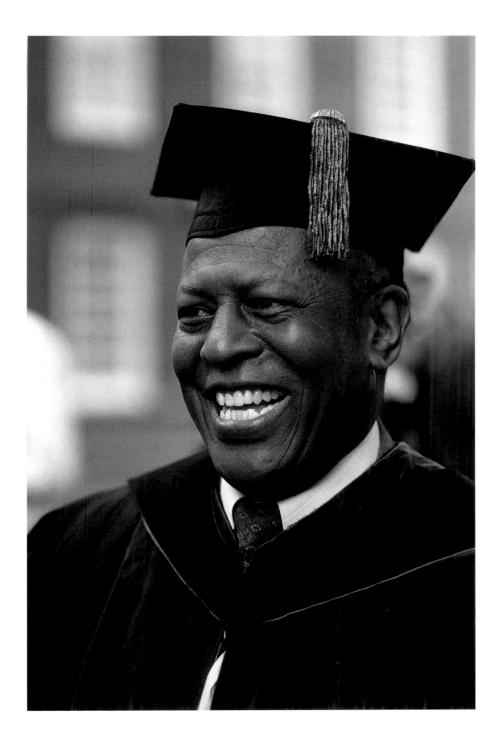

School of Education professor

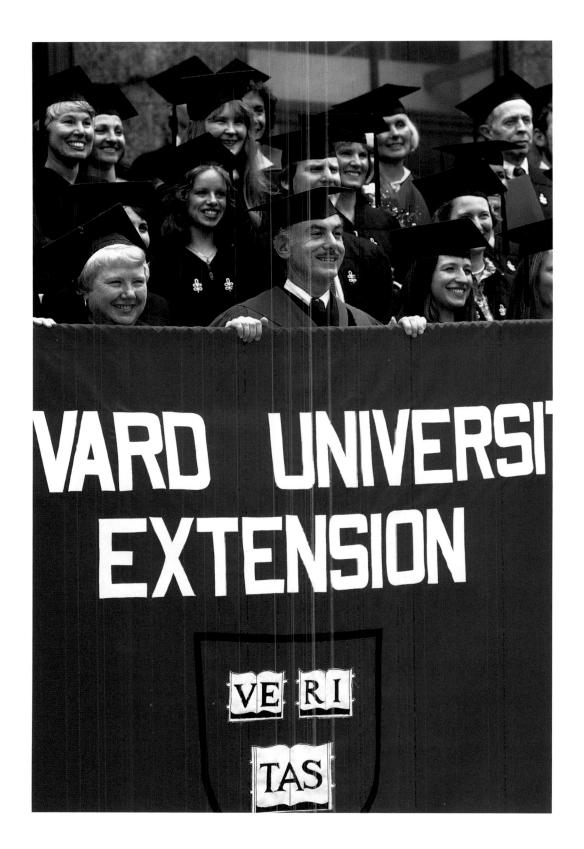

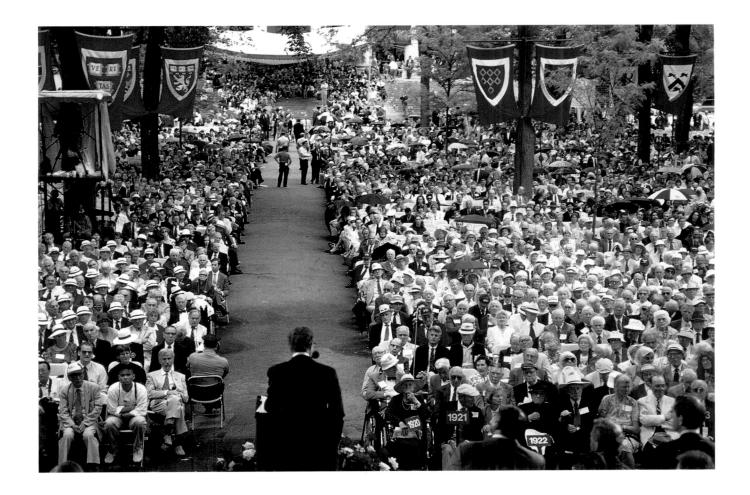

Alumni address, Tercentenary Theater

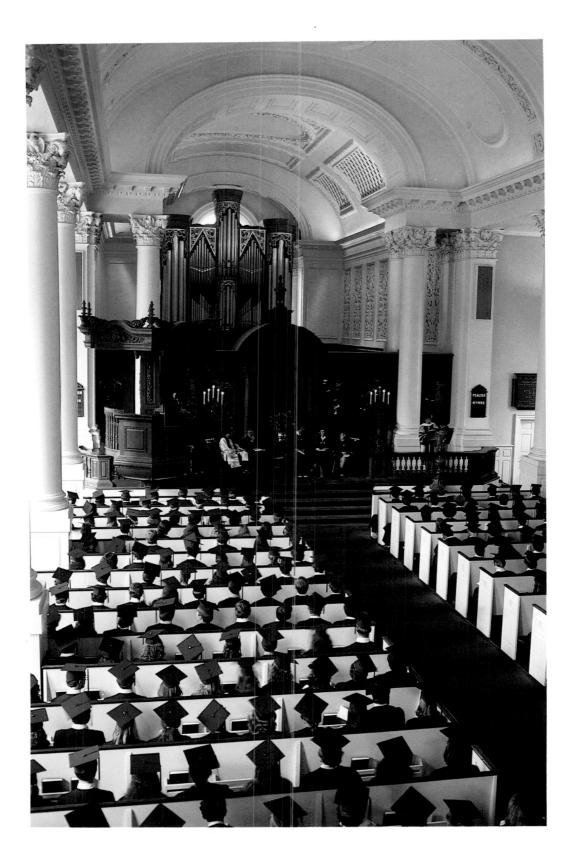

Baccalaureate address, Memorial Church

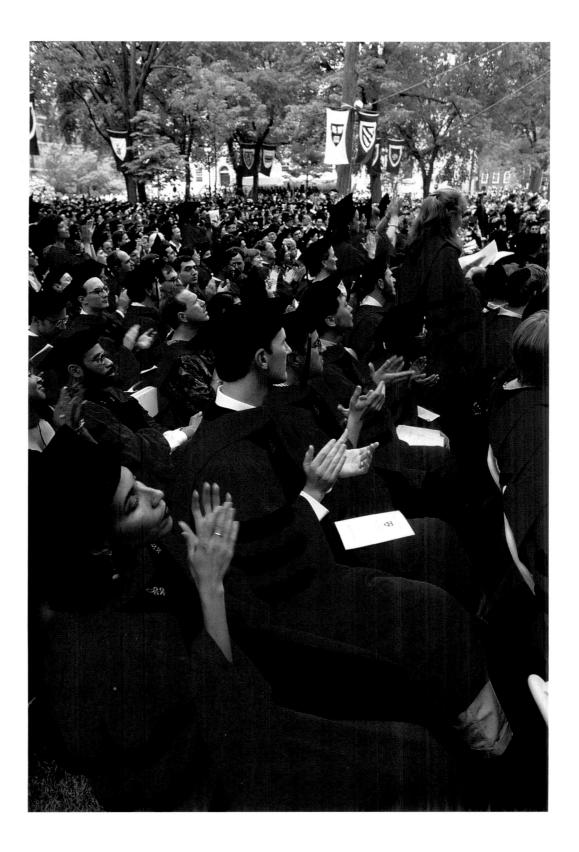

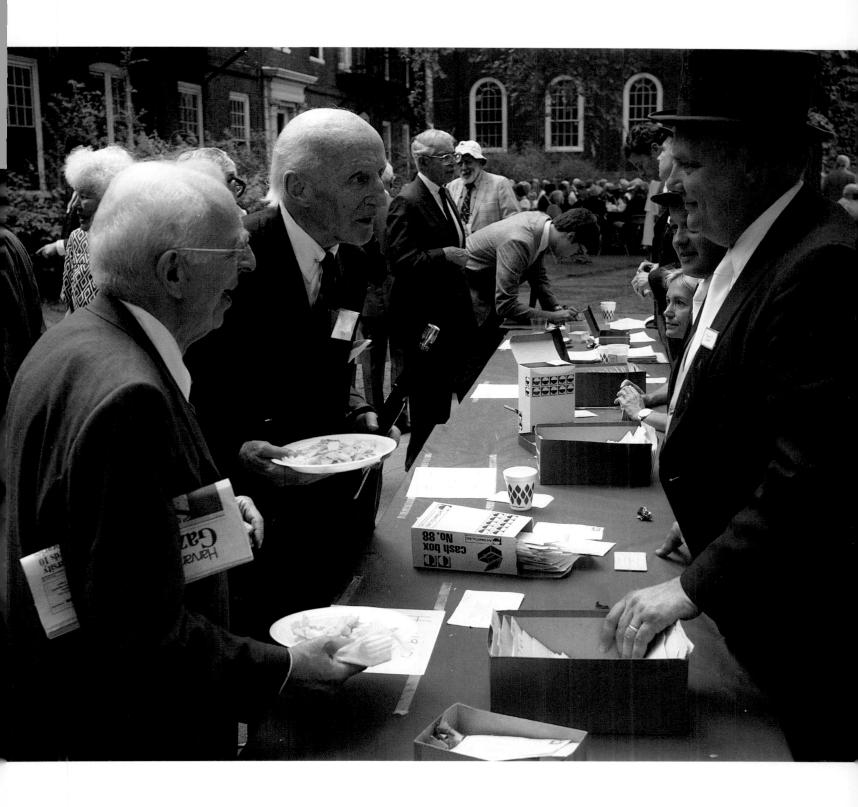

The "Tree Spread" lunch, Holden Chapel

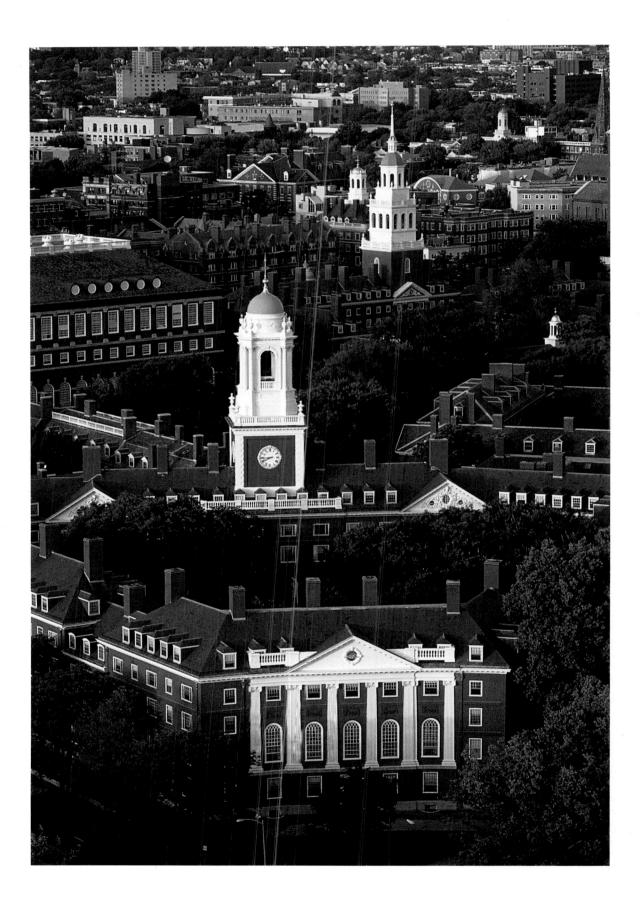

Eliot and Lowell houses

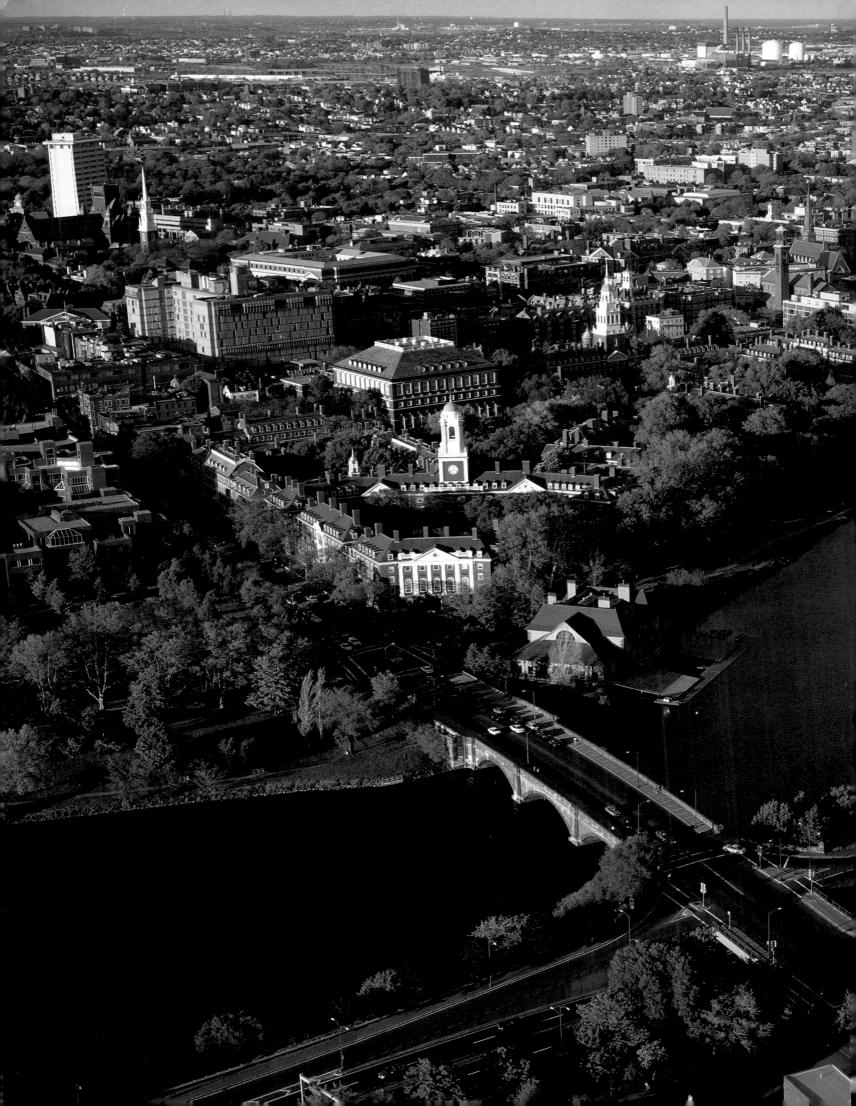

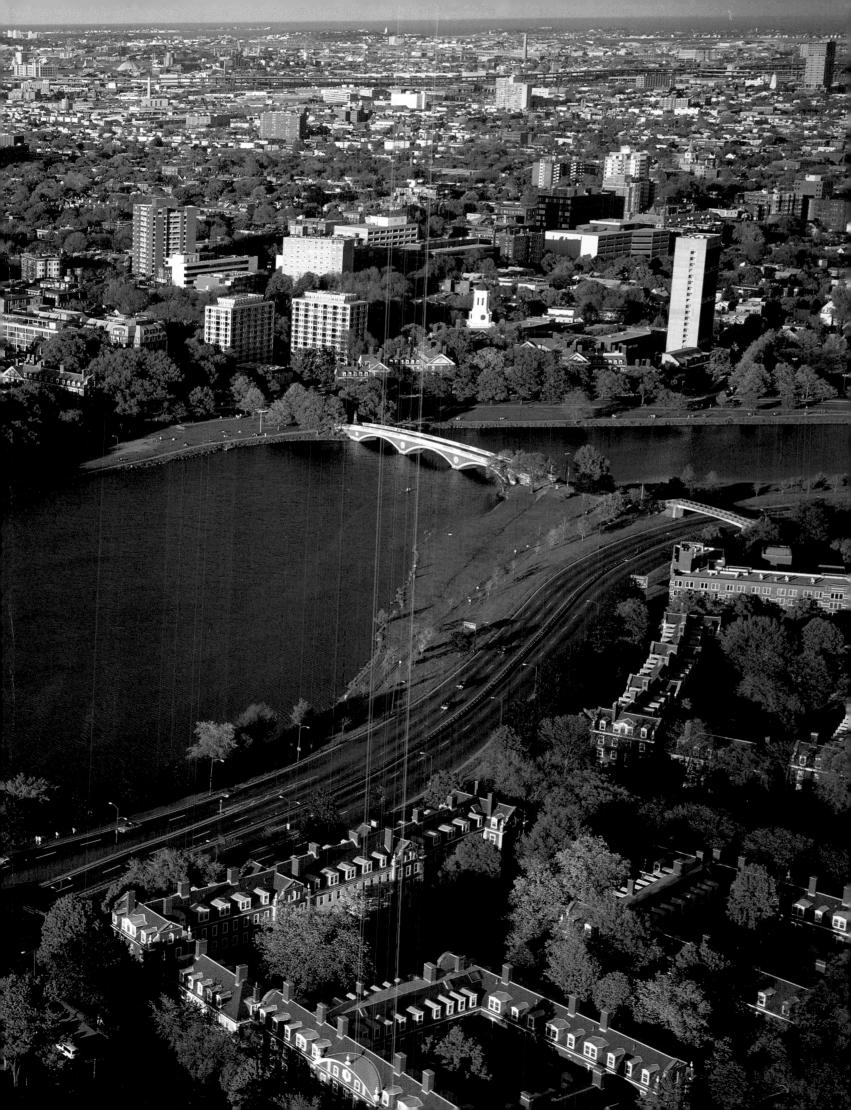

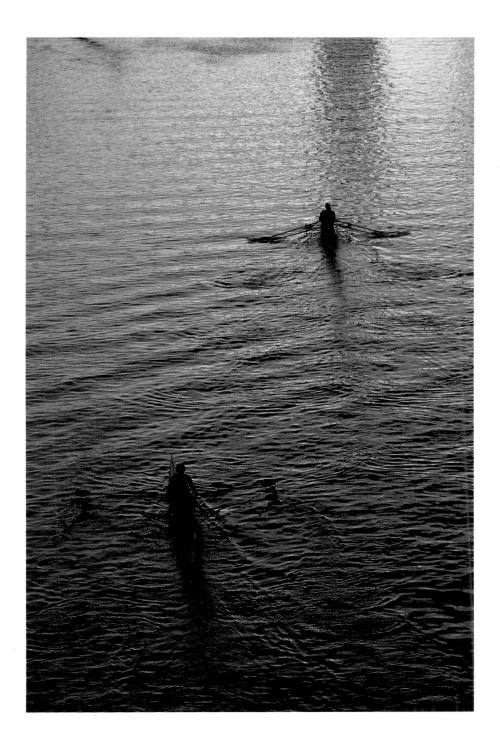